HAYWARDS HEATH

THROUGH TIME

Colin Manton

AMBERLEY PUBLISHING

Acknowledgements

Every reasonable effort has been made to trace and acknowledge existing copyright owners of material reproduced in this book. Details of any omissions should be directed to the publisher so that any corrections can be made in future editions. Thanks to the following for help and advice: Dr Cyndy Manton; Donald Stevens; Rendel Williams; Martin Hayes, County Local Studies Librarian, Worthing Library; Phillipa Malins and Sue Burgess, Honorary Curators, Cuckfield Museum; Nichola Court, Search Room Archivist, West Sussex Record Office, and colleagues; Jenny Lund, Curator of Fine Art, Brighton Museum and Art Gallery; the Sealed Knot Society. Thanks to the following for permission to reproduce photographs, postcards and maps: Donald Stevens, *'Bluebird'*; John Beardmore, 'Battle of Haywards Heath'; Alan Chambers, 'Haywards Heath Market'; Julia Skinner, Frith postcards; Mike Felbridge, 5, 6, 16, 28, 31, 33, 34, 35, 37, 48, 49, 50, 60, 62, 65, 66, 68, 72, 73, 74, 77, 82, 85, 88, 89, 91, 92; West Sussex County Library Service (www.westsussexpast.org.uk) 9, 10, 20, 24, 27, 29, 39, 40, 42, 51, 52, 54, 67, 87, 95; Dave Tucker 17, 21, 22, 23, 36, 38, 43, 56, 58, 59, 63, 71, 76, 81, 84, 90; Sussex Archaeological Society 1638 Map, West Sussex Record Office. Books consulted include: Nairn, I. and N. Pevsner, *The Buildings of England: Sussex* (1965); Cooper, V. W., *A History of the Parish of Cuckfield* (1912); Ford, W. K. and A. C. Gabe, *The Metropolis of Mid-Sussex* (1981); Thomas-Stanford, C., *Sussex in the Great Civil War* (1910); Gregory, A. H., *Mid-Sussex Through the Ages* (1933); *Haywards Heath CC Centenary Handbook, 1897–1997*; Nicolle, M. *William Allen* (2001); Searle, M. V. *Down the Line to Brighton*; Stidder, D. And C. Smith, *Watermills of Sussex, Vol. II West Sussex* (2001); Eyles, A., F. Gray and A. Readman, *Cinema in West Sussex* (1996); Glover, J., *Sussex Place Names* (1997); Margary, I. D., *Roman Ways in the Weald* (1965); Harris, R. B., *Haywards Heath Historic Character and Assessment Report* (2005). Websites consulted include: Memorial – www.roll-of-honour.com; Listed buildings – www.britishlistedbuildings.co.uk; Archaeology – www.archaeologyse.co.uk; Bluebird – www.rceasussex.org.uk. Museum, Library and Archive collections consulted include: Cuckfield Museum: Goldings Hotel auction sale particulars 1934; Mid-Sussex trade directories; 'hospitals' files. West Sussex Record Office: *Souvenir Guide* and *History of Haywards Heath and District*, 1911/12; Hilton's Archive Add MS 54801, 54798, 54799-54802, 54814-54820, 54821, 54822-54825; the Garland Collection; the Rogers Collection. Haywards Heath Library: Haywards Heath reference files.

In memory of our mother and father who married and chose Haywards Heath in 1938

First published 2013

Amberley Publishing
The Hill, Stroud
Gloucestershire, GL5 4EP

www.amberley-books.com

Copyright © Colin Manton, 2013

The right of Colin Manton to be identified as the Author of this work has been asserted in accordance with the Copyrights, Designs and Patents Act 1988.

ISBN 978 1 4456 0902 7

British Library Cataloguing in Publication Data. A catalogue record for this book is available from the British Library.

Typeset in 9.5pt on 12pt Celeste.
Typesetting by Amberley Publishing.
Printed in the UK.

Introduction

Haywards Heath has a distinctive and fascinating history, although it is often described as a new town without any past. The town may have become 'large' (present population around 23,000), but it is certainly not 'quite amorphous' – to quote the words of Nairn and Pevsner in 1965. In fact, there is visible evidence of Haywards Heath's existence in medieval times. Even earlier than this, traces of an old Roman road survive, running southwards through the western fringes of the town. This route probably served the early iron industry for which the district was once famous.

Centuries later, the old road was paralleled, somewhat to the east, by construction of a great 'iron road', or the London to Brighton railway, spectacularly hewn across an empty heath in 1841. This new railway opened up not only the immediate area, residentially, industrially and commercially, but also the whole of Sussex and beyond. Haywards Heath itself developed on either side of the great Victorian railway cutting, beginning immediately around the station. Originally no more than an essential railway halt on a great expanse of heathland, Haywards Heath rapidly expanded. It soon eclipsed the two hitherto dominating market towns of the area (as they could then be called) – Cuckfield to the west and Lindfield to the east. Both of these ancient centres conservatively resisted the railway. Vested interests saw it as a threatening imposition on local landowners and upon traditional businesses.

It was the careful selection of Haywards Heath, the new railway halt at the very centre of the county, as the site for the extensive and imposing Sussex County Asylum, opened in 1859 a mile or so south of the station, that led to further expansion and really established the importance of this urban 'upstart', midway between the two older communities.

Historically, a scattered settlement of manors, farmsteads, tracks, inns and mills, originally called 'Haywards Hoth', had occupied its important site in Mid-Sussex, long before the present modern, urbanised landscape appeared. A fascinating old map of the 'manor of Haward Hoth and Trubweeke', drawn up in 1638, furnishes vivid evidence of a thriving local settlement, flanked by Cuckfield in the west and Lindfield in the east, surviving parts of which are still surprisingly recognisable.

The strategic potential of the site of Haywards Hoth, situated on one of the county's chief lines of communication, is indicated by the great clash of arms that occurred locally during the English Civil War in 1642, at which a Parliamentary force put to flight a larger Royalist army. The Cathedral city of Chichester to the west, naturally loyal to the monarch, was the place from which the Cavaliers had ambitiously sallied forth, planning to attack the fiercely independent county town of Lewes to the east. The Royalists were routed somewhere in the area. It was a significant if relatively small-scale military victory for Parliament. The Royalists were effectively denied the munitions stored at Lewes and also stopped from ultimately capturing the commercially and militarily vital Cinque Ports further to the east.

In the 1930s, Arthur Pannett, the architect son of one of the town's acknowledged 'founding fathers', the builder Richard Pannett, gave a talk to the local Townswomen's Guild, describing an imaginary walk through the district before the construction of the railway. Mr Pannett emphasised that there were only two routes and, astonishingly, a mere dozen or so buildings would have been discernable from them. The following illustrations roughly follow Mr Pannett's walk and highlight many of the inevitable changes that time has brought.

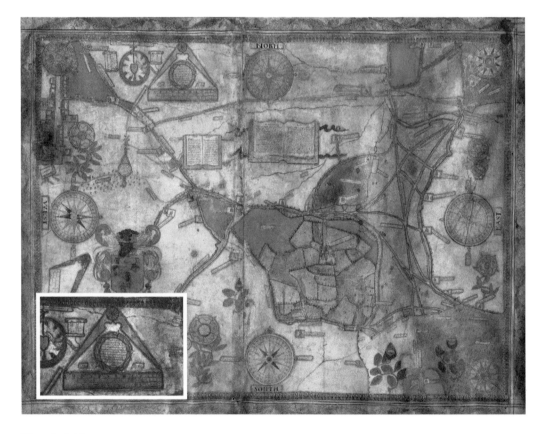

The 1638 Map

A fascinating and exceptionally detailed map entitled 'The Surfiece of the Land belonging Vnto Nicholas Hardham and his heireses of the waste lands of the manor of Haward Hoth and Trubweeke Taken by the Scale of Twentie pearch in one Inch by James FitzOberne the Twentieth Day of July Anno Domini 1638' is kept at West Sussex Record Office. Many of the old map's features are visible today: Butlers Green House, Steeple Cottage, the Dolphin public house and Muster Green. *West Sussex Record Office Add MS 28,784/Sussex Archaeological Society.*

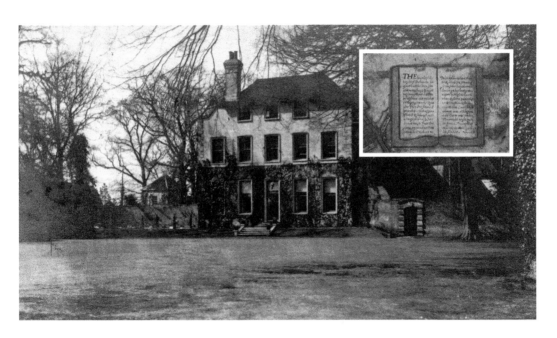

Butlers Green House, 1908

This impressive building, the former manor house of Trubweeke, appears on the 1638 map as 'Wardens House and Lande'. The oldest parts are Elizabethan and Georgian. The house is named after the Boteler family, who owned land locally for over 150 years from the late fourteenth century. In 1612 the house was purchased by John Warden, founder of the Warden/Sergison dynasty of Cuckfield Park. It was associated with a macabre local legend recounted by 'Wayfarer Senior' in *Sussex Daily News*, 19 April 1938. *Inset: 1638 Map, West Sussex Record Office Add MS 28,784/Sussex Archaeological Society.*

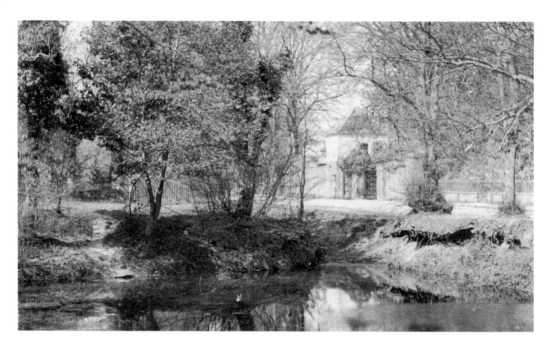

Butlers Green, 1908

The deep pond on the Green has long since been filled in. Wayside ponds served to water the horses. According to legend, a 'lady in grey' haunted the closed gate at the front. The old chain could be heard rattling when she appeared. It was said that she was banished by her husband, who was convinced that she had taken a lover. She fled in darkness with her infant child in her arms and fell into the pond. Tragically, they drowned.

Toll Gate, Butlers Green, 1854
The date 1854 is pencilled upon this old photograph, which shows a contrast to today's traffic on the A272. As Haywards Heath grew, this route to the new railway station was used more and payment of tolls became seriously irksome. In 1866 it was agreed that future tolls should be commuted on payment of a lump sum to the turnpike trustees. The gates were ceremonially burned at Hatchgate Farm, 'amid general rejoicing' (Cooper, 1912). *Top: Cuckfield Museum.*

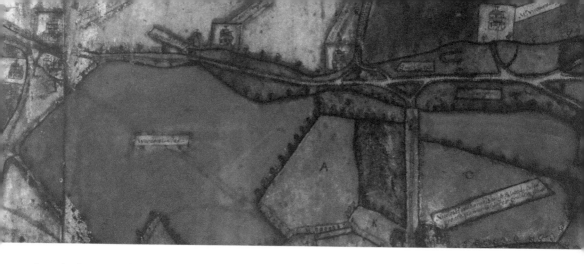

Steeple Cottage, 1638

This was the first dwelling mentioned by Mr Pannett on his walk, but it is barely visible today. It appears on the 1638 map as 'Court House'. In 1851 it was called 'Steeple House' and occupied by Thomas Jenner, a local carpenter. A large Gothic arch on the west wall has puzzled local historians. Possibly the house was 'originally part of a larger structure and over the centuries a chapel, barn, court house and finally, private dwelling' (Ford and Gabe, 1981). *Top: 1638 Map, West Sussex Record Office Add MS 28,784/Sussex Archaeological Society.*

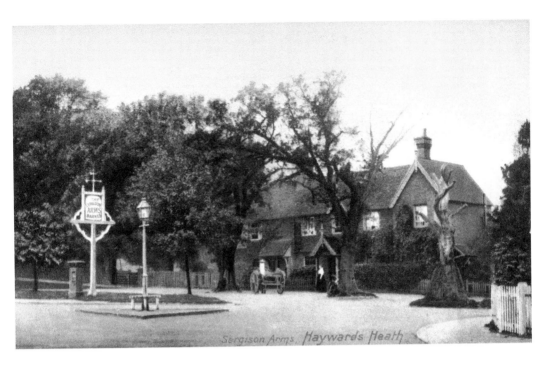

The Sergison Arms, 1906

Described on Pannett's walk, this is Haywards Heath's oldest public house. It appears on the 1638 map as 'Hen Davis House and Lande'. In 1832 the old farmhouse seems to have become an inn called the Dolphin (probably from Sergison coat of arms.) By 1845 the inn had become the Sergison Arms. The local hunt formerly assembled here. It was renamed the Dolphin again in recent years. The chimney on right has disappeared; the tile cladding is modern.

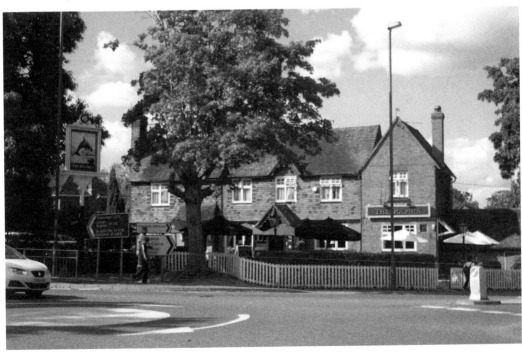

Muster Green, c. 1910

This grassy area is still an attractive feature, despite the heavy traffic on the A272. The trees have recovered from the 'hurricane' of 1989. Pannett mentions that the Green was once about three times larger. It is said to have been a seventeenth-century mustering place for units of the national militia. In the nineteenth century, the annual Dolphin Fairs or pig markets were held here, with 'unlimited supplies of beer, spirits, bread and cheese' (Ford and Gabe, 1981).

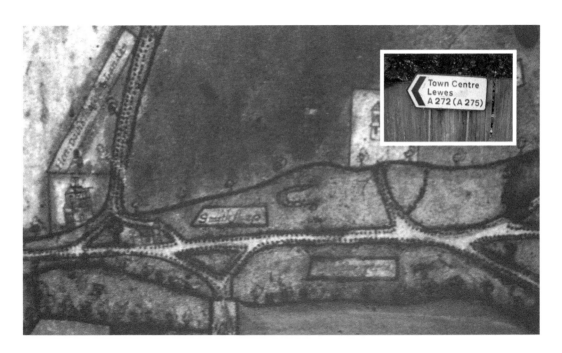

The Battle of Haywards Heath, 1642

Muster Green is discernable on the 1638 map, possibly the site of the Battle of Haywards Heath in 1642, which was re-enacted by the Sealed Knot Society at Glynde Place in September 2012. 'On leaving Cuckfield in the first week of December,' the Royalists encountered a 'somewhat less numerous Parliamentary force'. Parliament inflicted 'a loss of 200 or more' on the Royalists. The levies fled to local villages and the officers galloped back to Chichester. *Top: 1638 Map, West Sussex Record Office Add MS 28,784/Sussex Archaeological Society; bottom: John Beardmore.*

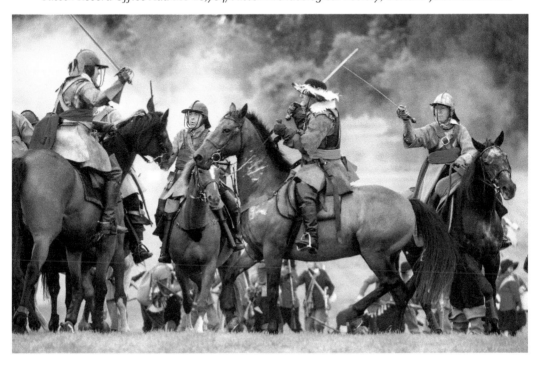

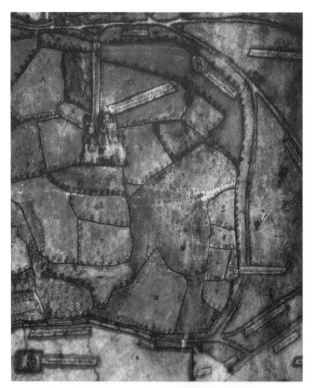

Great Haywards Farm and Little Haywards Farm, 1638

Shown on the 1638 map as 'Nicholas Hardham his house and lande called great Haywards', Great Haywards, a late fifteenth-century timber-framed former farmhouse, still stands just south of Muster Green, down Oakwood Road, off Amberley Close. To the south-east in Courtlands, off Haywards Road, a timber-framed hall house of about 1400 also survives, named 'Nicholas Hardhams house'. The separate manors of Haywards and of Trubweeke were combined under Nicholas Hardham's ownership to form the future nucleus of Haywards Heath. *Top: 1638 Map, West Sussex Record Office Add MS 28,784/Sussex Archaeological Society.*

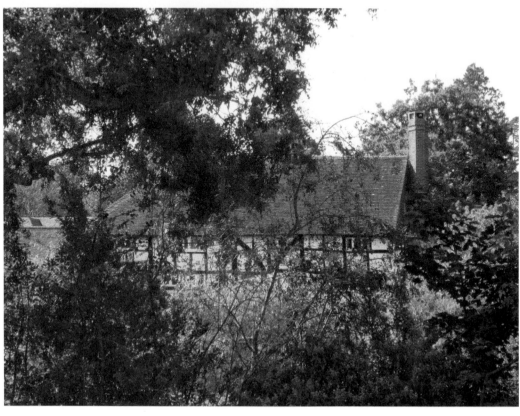

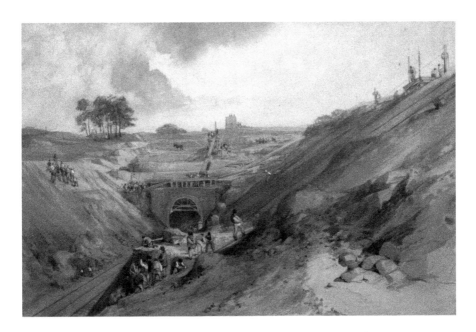

Haywards Heath Tunnel in the Course of Construction, 1841

This detailed watercolour by George Childs shows the digging of the railway tunnel under Muster Green, a difficult and hazardous task for the hundreds of 'navvies', as the railways workers were known. Here the work relied on muscle power, as shovels, picks, wheelbarrows, pulleys and winches were used. At the peak, 5,000 men and 50 horses were employed. Above the tunnel, the circular brick towers of two ventilating shafts are under construction, both of which survive. Commuter trains emerge from the same tunnel. *Top: Cuckfield Museum.*

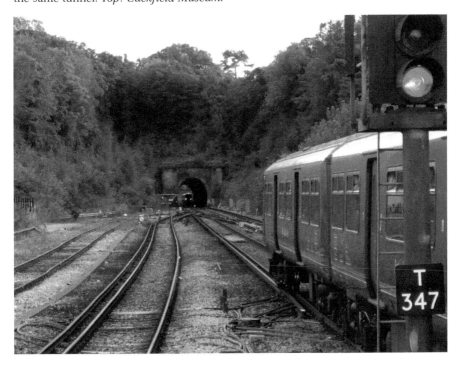

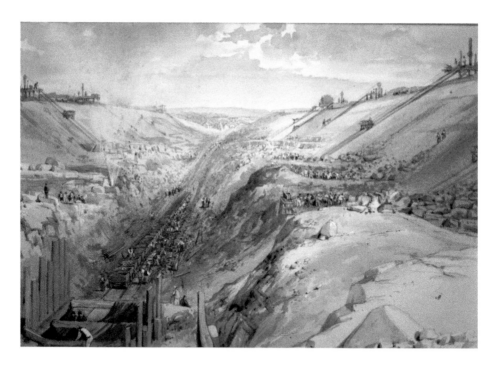

The Line South of Haywards Heath Tunnel, 1841
This second atmospheric watercolour by George Childs shows the continuation of the railway cutting immediately south. The extra power provided by a charge of gunpowder shatters a stubborn rock. At the lower left, building work is underway on the southernmost of the two brick ventilation towers. This tower is visible in the private grounds of the present Muster Court. The second or northernmost tower stands in Muster Green car park. *Top: Royal Pavilion and Museums, Brighton and Hove.*

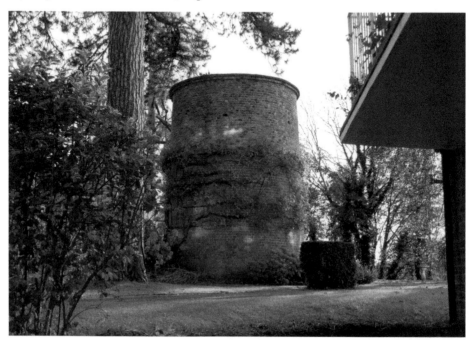

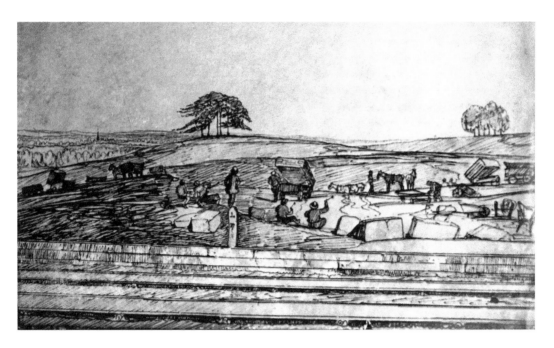

Lindfield from Haywards Heath Station, London to Brighton Railway, 3 November 1841
Unusually, this appears to be an old photograph of an original anonymous drawing. Running along a low embankment, the original tracks are clearly visible. Navvies work with hammers to complete the track for the first trains. The line opened on 12 July 1841, but the section to Brighton had to be completed by horse-drawn coach. Trees, the large billboard and the modern station's superstructure completely block the distant view of Lindfield to the east. *Top: Cuckfield Museum.*

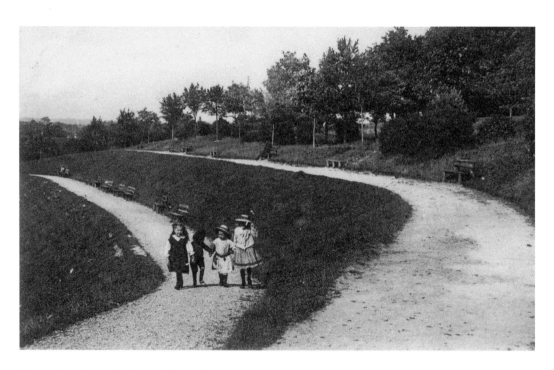

Recreation Ground, Haywards Heath, 1908

The unspoiled remnant of the original heath, visible in the previous drawing, was purchased by public subscription, vested in the local board and designated as a Queen Victoria Golden Jubilee memorial in 1887. Mr Jireh Knight donated 100 trees (Ford and Gabe. 1981). Looking at the same scene in 2012, the year of the present Queen's Diamond Jubilee, 'the rec' and the paths appear surprisingly unchanged, although people behave and dress very differently.

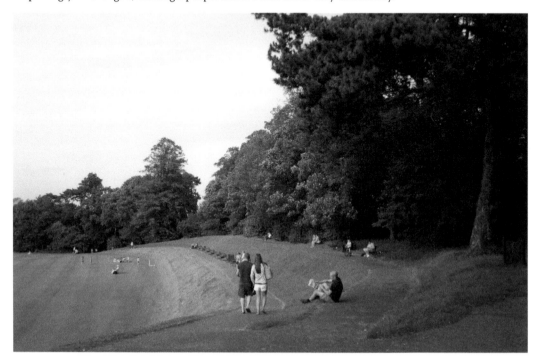

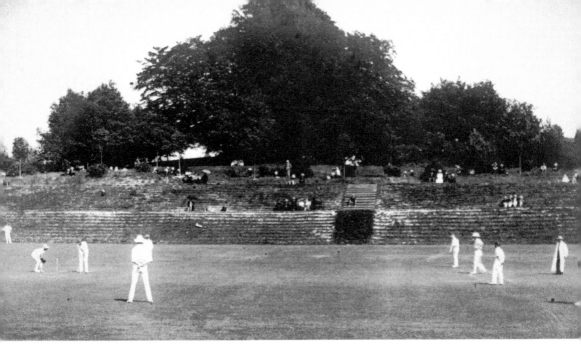

Recreation Ground, Cricket Week, 1910

One of the finest grounds in the county, the cricket area began as an unlikely 'boggy water course ... fouled with rubbish and house refuse' (*HHCC Centenary Handbook*, 1997). Works devised by Mr Jesse Finch, a leading local builder, were completed by the new Urban District Council in 1894. The ground was opened on the occasion of the Queen's Diamond Jubilee, 1897. In 1911, the young Maurice Tate played for the club before he joined the Sussex team and was picked for England.

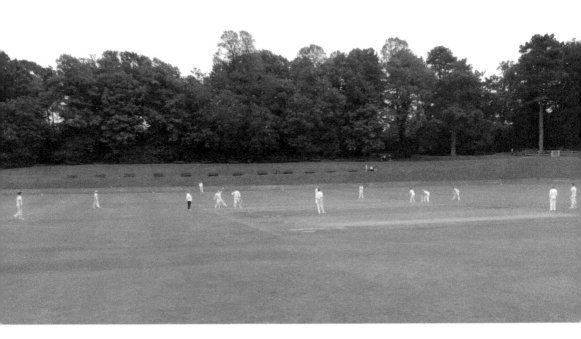

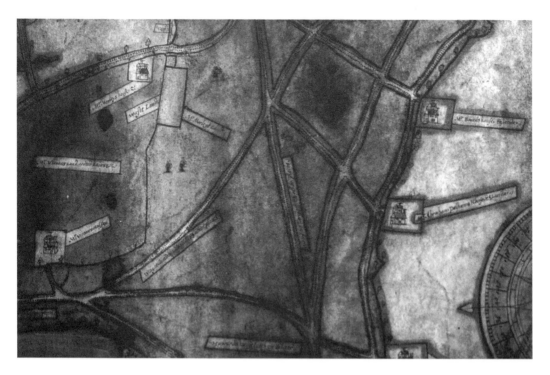

The Old Track Across the Heath from Haywards Heath to Lindfield, 1638
Mr Bannister, prominent auctioneer, chairman of the Urban Council and president of the cricket club, opened the first pavilion at the close of the 1904 season. The pavilion was renewed and upgraded in 1964. The present path was mentioned by Mr Pannett as the old track running across the heath from Haywards Heath to Lindfield, visible on the 1638 map. *Top: 1638 Map, West Sussex Record Office Add MS 28,784/Sussex Archaeological Society.*

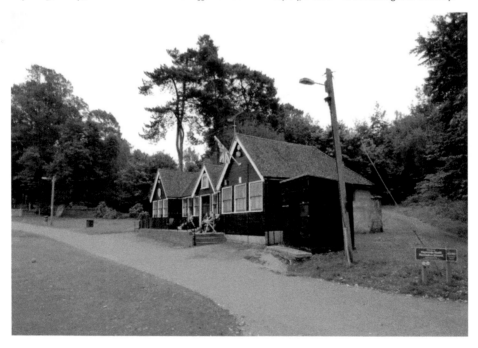

Highwayman bold was this Hayward, they say!
Across the heather he rode in his day;
Yellow the Gorsebush, and yellower gold
Weighted the pouch of the highwayman bold.
Alone, like Dick Turpin, over the moor,
Robbing the wealthy to favour the poor.
Desperate doings on the King's highway—
"Stand and deliver!" The devil to pay.

Mus' Penfold's Opinion

Highfly be the tales, an' I can't agree,
Explain 'em however they likes to me;
All of the Haywards I knowed in my day
Tallies with what I be bolden to say:
"Haywards" was ol'-fashioned keepers of hay!

'Highwayman Bold' Legend, Early Twentieth Century

Legends of the highwayman proved remarkably persistent, as this early twentieth-century postcard shows. The vicar, the Revd Wyatt, even felt that it was undesirable for the town to be named after a villain (Hayward), and recommended a 'rebranding' to St Wilfrid's, after the church. Neither the railway company nor the Post Office was interested. The tradition survives in the names of the optional routes of the local cycling event, seen here at the west corner of the aptly named Heath Road. *Top: Rogers Collection, West Sussex Record Office.*

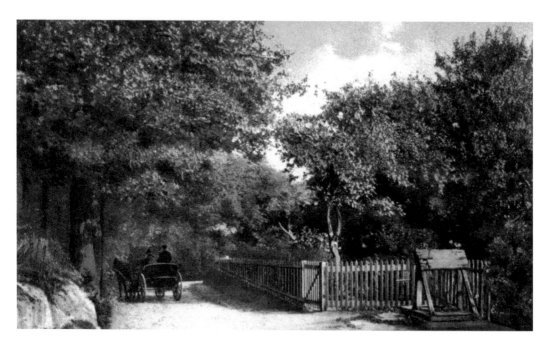

America Lane, 1910

On the route eastwards to Lindfield, this once picturesque picnic spot, famed for local strawberries, now consists largely of mid-twentieth-century social housing. Modern allotments amid the houses retain something of the previous rural idyll. The district's 'American' names – New England Road and Boston Road, for example – have their origins in the pioneering social works of the prominent local Quaker, chemist and philanthropist, William Allen, who founded a 'colony' for the poor in the early nineteenth century (Nicholle, 2001).

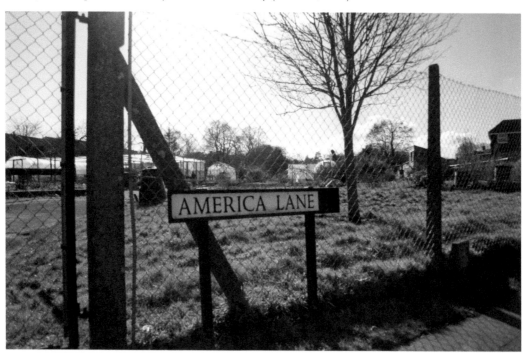

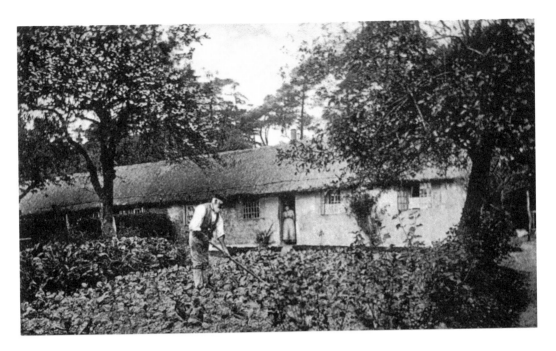

Gravelye Cottages, Lindfield, 1911

The 'colony' was styled 'America' on 1870s maps, and consisted of a small group of cottages with land for crops. The 'Gravelye Cottages' were rented to the 'industrious poor'. The experiment 'was like a small America to the people of the area' (Nicolle, 2001). The cottages were finally demolished in the 1940s and 1950s. Nearby, but very different in concept, the present Franklands Village, successfully developed in the 1930s by the Rotary Club (architect H. G. Turner), also aimed to make affordable housing available.

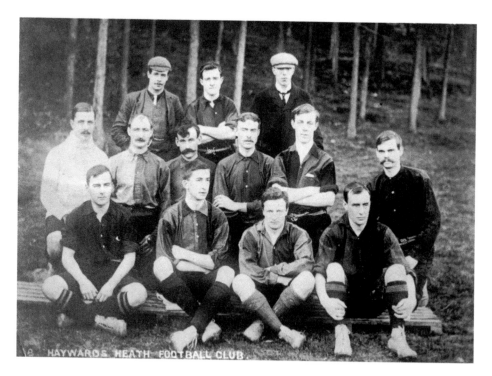

Haywards Heath Football Club, 1906

Formed in 1888 as Haywards Heath Junior FC, the team's home ground was Victoria Park, later Hanbury Park Stadium. After several name changes, the club became Haywards Heath Town FC, 'the Blues', in its centenary year. As to the stadium's name, the opening ceremony programme on Saturday 23 August 1952 said it was a historic site – the 'America' cottages had stood nearby. Their founder, William Allen, had founded Allen & Hanbury, a great pharmaceutical company, famous for pastilles.

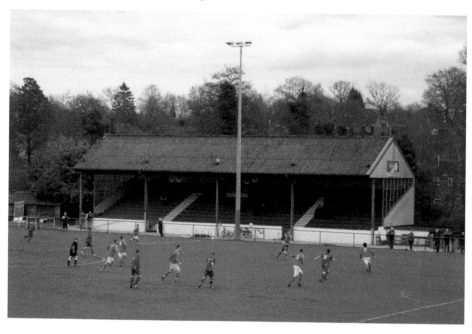

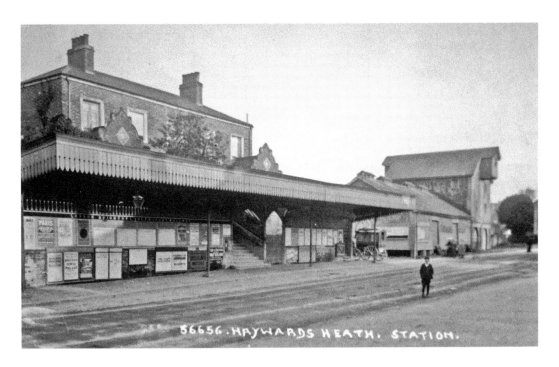

Haywards Heath Station, 1908

To Mr Pannett, active in local dramatics, the railway was the 'Prince Charming' that awakened the 'Sleeping Princess' (Haywards Heath) from her slumbers. In his day, the station looked very different – the original main entrance faced west across Market Place. It was flanked by a large, tile-hung corn store on the right – agricultural compared with the distant 1960s office block visible today. Interestingly, after years of being a mere side entrance, this has been recently upgraded, although the main entrance remains around the corner, facing north.

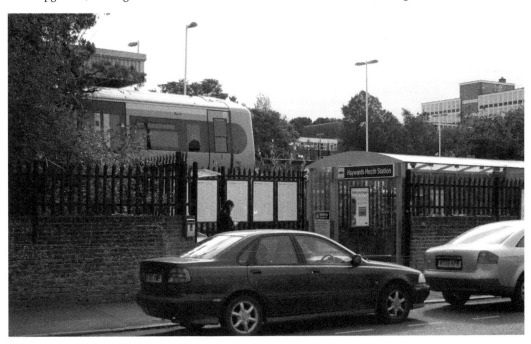

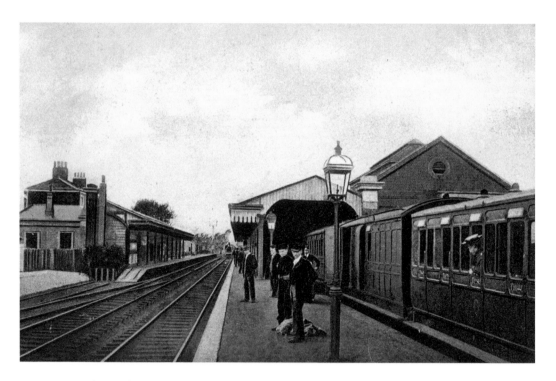

Haywards Heath Station, 1905

Although much modernised and lengthened, the platforms do not look markedly different today although the station's Victorian entrance, superstructure, signal box and goods facilities have been demolished. The railway caught on fast – in the first operational week to Haywards Heath, 2,483 passengers paid £925.30 in fares. Brighton was not actually connected until 21 September 1841. The big event, the first 'down' train from London to Brighton, may have had eighteen carriages and crawled into Brighton after a 2½ hour journey.

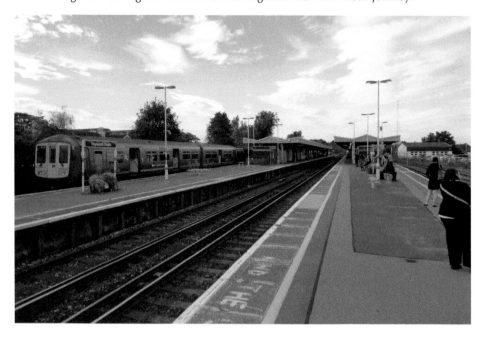

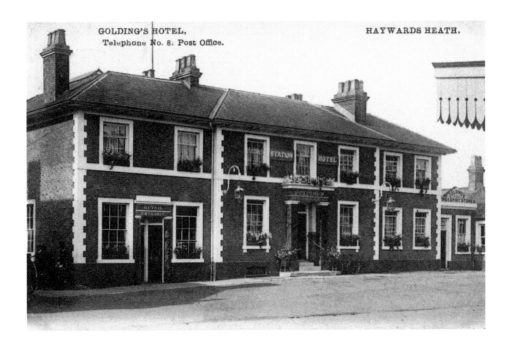

Goldings Hotel, 1912

The Messrs Knight, Frank & Rutley auction particulars of 1934 list a coffee room, smoking room, public bar and a billiard room above. The noted 'Market Room' was over 25 feet by 40 feet. 'On market days certain tables, eight in all, are occupied by various firms, and by the Inland Revenue.' The low extension on the right was the town's corn exchange. The premises (then the Heyworthe Hotel) were converted to offices in the late 1980s.
Top: Rogers Collection, West Sussex Record Office.

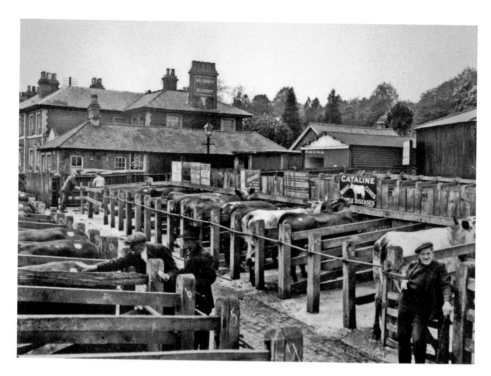

Haywards Heath Cattle Market, 1920s

In 1868, Mr T. Bannister established a fortnightly (later weekly) stock sale. The 1934 particulars refer to 'part of the cattle market comprising a highly important site immediately facing Haywards Heath Station and having a frontage of about 142 feet to Market Place'. The lot covers an area of 27,000 square feet, including 'Two Brick and Slated Sheds and a Timber and Iron Roof Shed'. A car park and apartments (formerly 1960s offices) stand on the site. *Top: Garland Collection, West Sussex Record Office.*

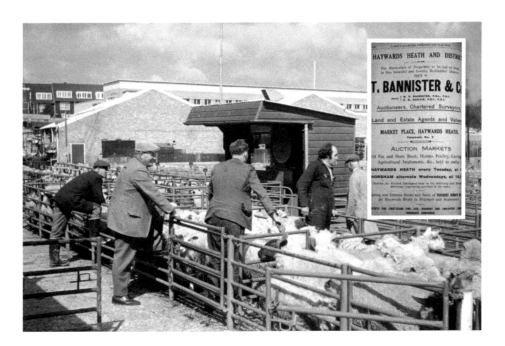

Haywards Heath Cattle Market, 1969

The cattle market, one of the twelve largest in the UK, was moved some 300 metres north to a new site, now covered by the Sainsbury's superstore car park. About 100,000 stock were sold each year. Residents would experience a 'farmyard smell'. Cattle were unloaded from trucks in a nearby railway siding and herded down the embankment into pens. On market days in the 1950s, over 100 cattle lorries would arrive. The market closed in 1989 and the superstore opened in 1991. *Top: Alan Chambers.*

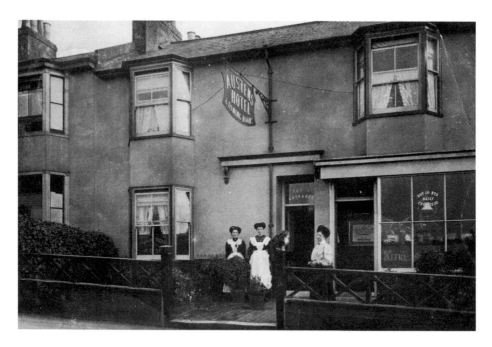

Austens Hotel, 1908

Parts of Haywards Heath have been redeveloped beyond recognition. An example is Clair Road, formerly Station Road. Terraced dwellings led to railway cottages, a pub and the rear entrance of the station in the late nineteenth century; today, most of the old buildings have disappeared and their replacements have been given over to offices and alternative health practitioners. Austen's hotel stood here, a temperance establishment that served 'hot joints daily from 12.30'. The old picture almost conveys a smell of boiled beef and carrots.

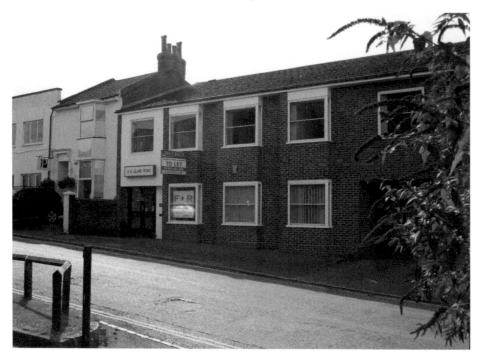

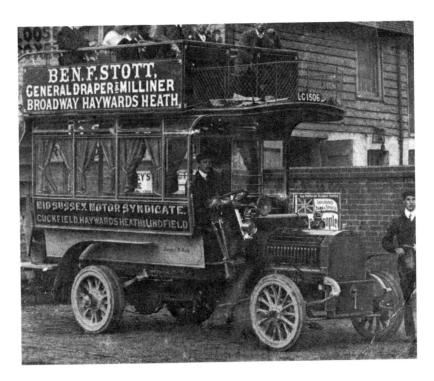

Haywards Heath's First Motor Bus, 1905

Although seen as 'a conservative sort of place', at least socially, the town was not shy of innovation. Motor buses were so new in this era that the service attracted considerable newspaper attention when the vehicle was driven from the manufacturer's in Guildford to its new base at the Liverpool Hotel, Station Road, where it was photographed. The service ran from Lindfield to Cuckfield via here. The modern bus, seen at the Dolphin, is massive compared with its predecessor.

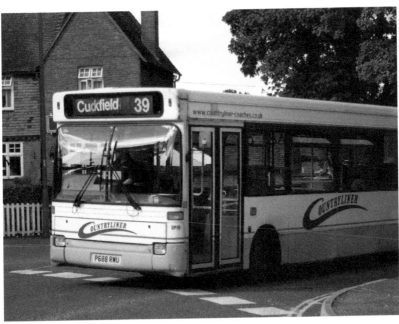

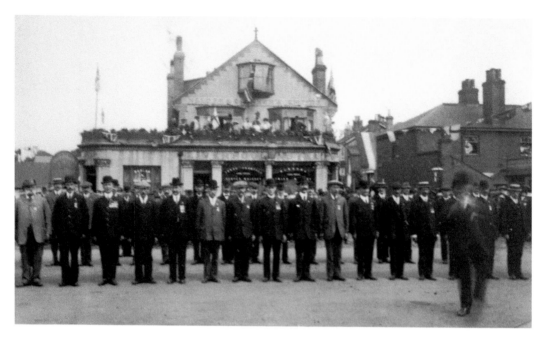

National Reserves Guard of Honour, Haywards Heath, 1912

This picture of the National Reserves Guard of Honour also shows one of Haywards Heath's lost historic buildings, the Liverpool Hotel, also known as the Liverpool Arms. According to hearsay, it was named in honour of the railway navvies, whom locals believed hailed from Liverpool. The pub was literally and metaphorically 'the other side of the tracks' from the more upmarket Goldings Hotel at the station front. The premises closed in 1990 and was demolished in 1997, leaving just a parking area. *Top: Cuckfield Museum.*

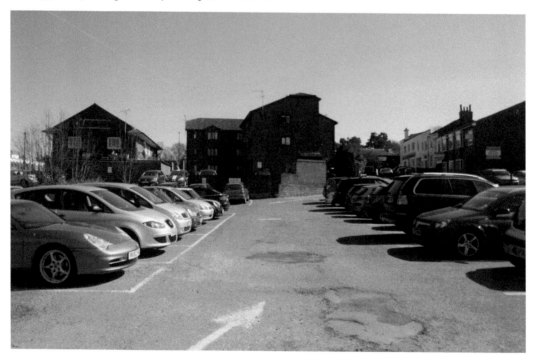

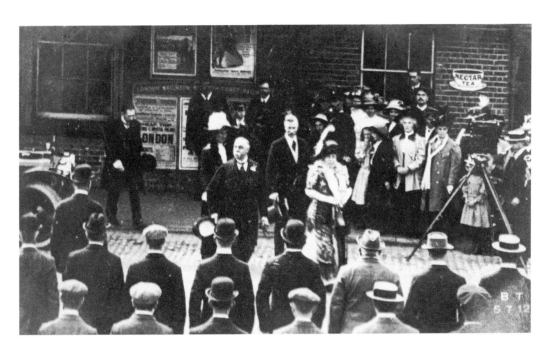

HRH Princess Christian Inspects the National Reserves Guard of Honour, 1912
It was Princess Christian's duty to open the local hospital. The old picture shows Her Royal Highness emerging from the station's rear entrance, facing Clair Road. An advertisement for Nectar tea is visible. More significant is the hand-cranked movie camera, operated by the manager of the town's first cinema, the Heath. The resulting highly topical film would have been almost instantly projected to audiences. As to the members of the National Reserves, they were militarily experienced men of more mature years.

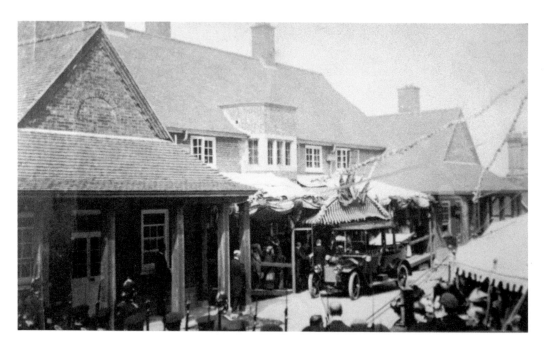

HRH Princess Christian Arrives to Open the King Edward VII and Eliot Memorial Hospital, 1912
When Miss Eliot died in 1904 she left £600 to establish a cottage hospital, Eliot House, in Ashenground Road. This was removed in 1912 to premises in Butlers Green Road (opposite Beech Hurst). The new hospital served as a memorial to the late King. The site was gifted jointly by Captain Sergison of Cuckfield Park and by Sir James Bradford of Oaklands. There were four wards. It was closed in the 1990s and redeveloped. Treatment was transferred to the new Princess Royal Hospital. *Top: Cuckfield Museum.*

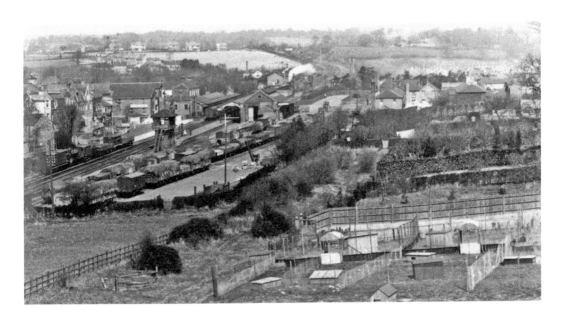

Haywards Heath from the Broadway, 1910

A view of the station, Haywards Heath's main focus, showing sloping land that had only recently been under the plough, passengers on the platforms, warehousing, goods yards and coal bunkers, corn store, banks and Goldings Hotel, and in the far distance, a white-painted water mill and chimney. The present view, dominated by car parking, taken from a slightly different aspect, is even leafier. Boltro Road, on the left, runs down to the station.

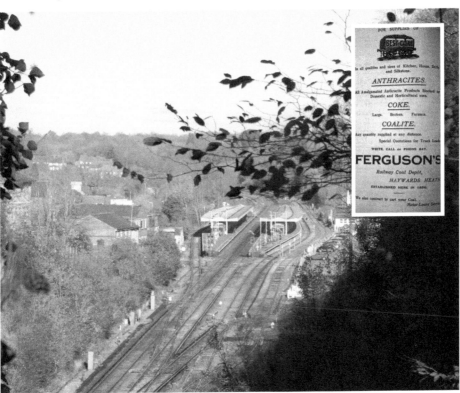

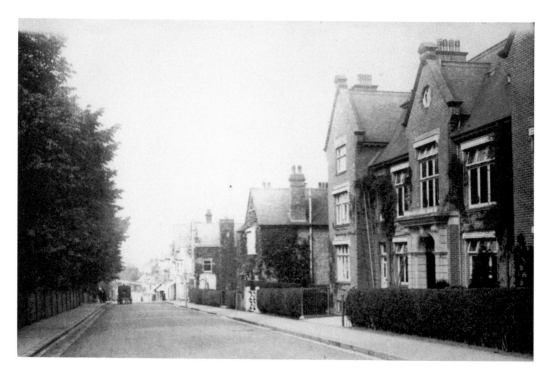

Boltro Road South, 1912

Mr Pannett preferred 'Bull Trough Road' to 'Boltro'. The name may actually derive from the even older 'Bolla's Tree'. This road radiated from the railway station hub as a concentration of a bank, utilities and local government offices. The old Cuckfield Rural District building is visible in the foreground, on the right. Waugh's solicitors and an imposing post office stood slightly further downhill. These were demolished. Heath Square and the social security offices replaced the old buildings in the 1990s.

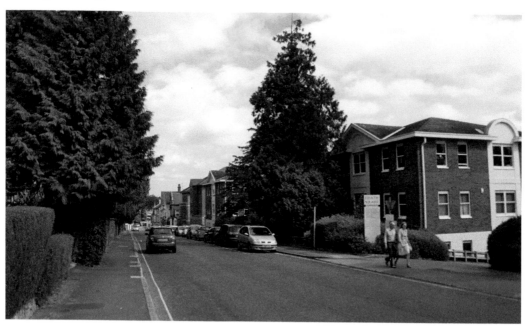

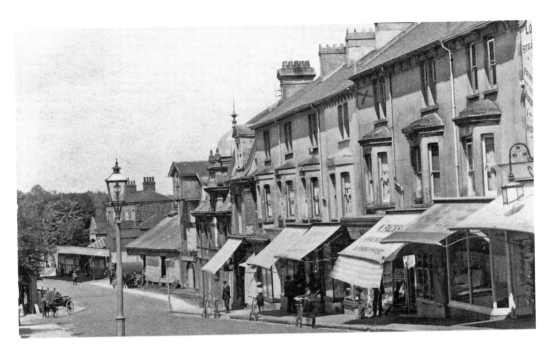

Boltro Road North, 1908

A fine parade of shops stood on the right lower down, nearer the station, just visible in the distance. Today they are less thriving. Canvas blinds protected the shop window goods from the sun and, incidentally, offered cover to shoppers and pedestrians on rainy days. Interestingly, Boltro Road has stayed partially green and residential on the left or west side. In contrast, its commercial rival, the Broadway, on the other side of the railway, became developed on both sides in the 1930s.

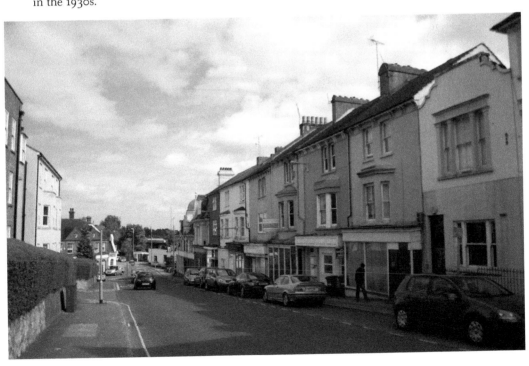

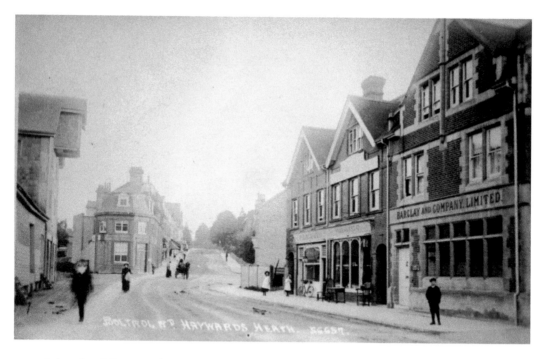

Boltro Road from Market Place, 1906

This faded but fascinating view shows the large Barclays Bank branch (now offices) in Market Place on the right and, on the left, the overhang of the lofty corn store. In the central background is an impressive domed office building, which became a branch of Lloyds Bank (now offices also). The new automated Market Place station entrance nearly obscures the old view, which changed dramatically shortly after the photograph was taken.

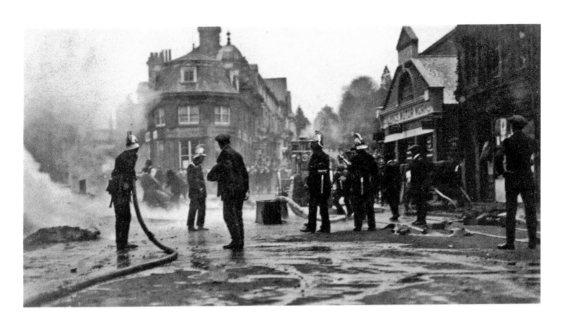

Corn Store Fire, 1915

This striking picture shows the fire brigade fighting a serious conflagration that resulted in the total destruction of Jenner & Higgs' corn store. The firemen wear smart brass helmets and closely direct their water hoses, but to no avail. A gap exists today where the old store once stood. On the right is Golding's garage. The premises are still run as a garage business. They were formerly occupied by Brown's garage, which began in South Road early last century and now trades from Burrell Road.

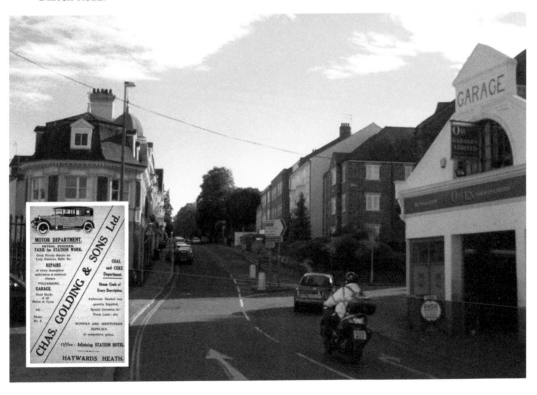

Boltro Road Corner, 1906

This photograph shows the petty sessional court house and the East Sussex County Police divisional headquarters of 1886. The Gothic-style buildings were a measure of Haywards Heath's importance, and a reminder that the town was in East rather than West Sussex before local government reorganisation in 1974. The *Souvenir Guide* compiled in 1911 mentioned the buildings' unpopularity with motorists prosecuted for speeding on the Brighton Road! This historic complex was demolished in the 1990s and replaced by the sympathetically designed Charter Gate apartments.

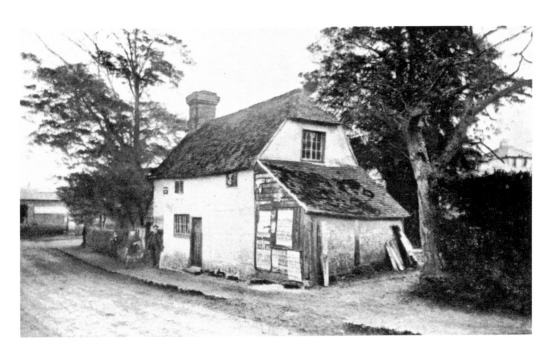

Dick Turpin's Cottage, 1908

This quaint old cottage was unsentimentally demolished in the mid-1880s, as Haywards Heath's powers grew, to make way for the previously mentioned Victorian court house and police station. Mr Pannett totally dismissed the dwelling's association with Dick Turpin, the notorious eighteenth-century highwayman. He knew from his boyhood experience living at Boltro Farm (now known as Old House) that this was simply a farm labourer's cottage on the Sergison estate. Nevertheless, the old cottage was evidence of the local tenacity of legend.

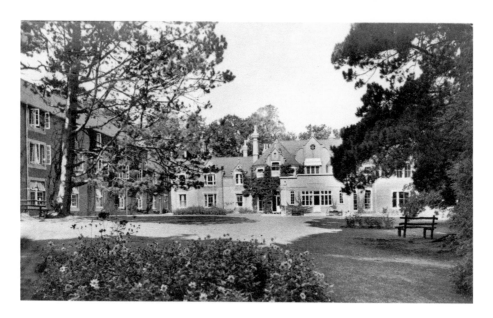

Elfinsward, Early Twentieth Century

A historically significant building, Elfinsward could be reached from the railway station by walking up Paddockhall Road to Butlers Green Road again. Elfinsward was a Church of England diocesan conference centre, situated just east of Beech Hurst, given by Mrs Gerald Moor to Chichester diocese and opened by Bishop Burrows in 1928. Elfinsward was later acquired by the Sussex Police Authority in 1975 and, after long delays and controversy, demolished for the new court house and police station, which opened in the early 1990s.

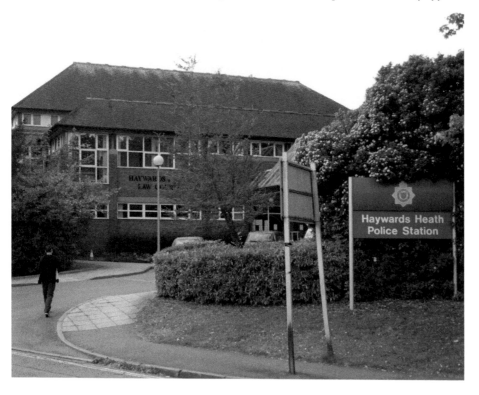

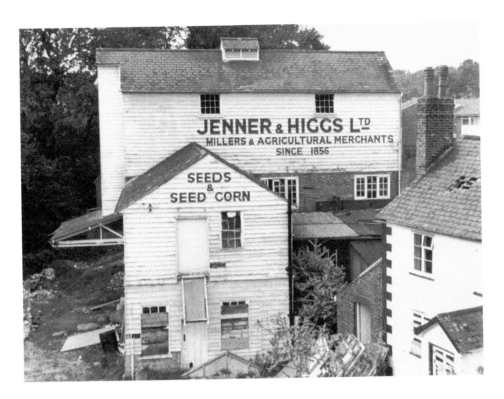

Jenner & Higgs' Mill, 1969

Another vanished but historically significant building. It was situated near the station, north of the present Sainsbury's car park, adjacent to the western edge of the railway embankment, which was driven through in 1841 when the building was only a year or so old. An earlier mill on the site is recorded on the 1638 map. The 26-foot overshot iron waterwheel powered five pairs of millstones. It was replaced after 1915 by steam, gas and electrical power. The mill was demolished in 1969. *Top: Kim Leslie, West Sussex Record Office.*

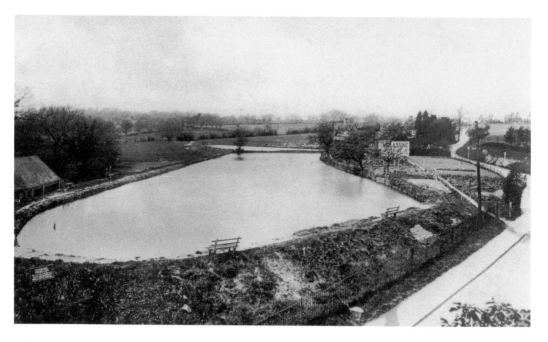

Mill Pond, Balcombe Road, 1908

Mention has already been made of the obliteration of Jenner & Higgs' corn store, adjacent to the station, in 1915. The old mill pond, fed by a tributary of the River Ouse, was the last survivor, but it was drained in 1964. Commuters lost an interesting view from their compartment at Haywards Heath. Housing now covers the site of the pond and the road cuts right through where it lay, from the north-west corner to the south-east corner.

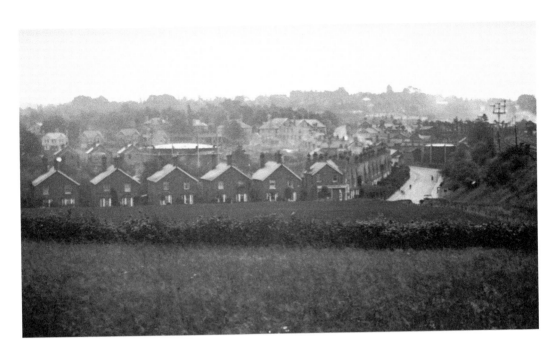

View from Wickham, 1908

Haywards Heath remained relatively rural as it grew. Seen from the cornfields of Wickham Farm, the town and distant church are visible to the south. The artisans' dwellings in College Road run across the foreground. In the mid-distance, Mill Green Road climbs up to Commercial Square, past the long-demolished gasometers to left and right. Haywards Heath fire station is on the old site of the gasworks on the right of the picture. Housing and the Mid Sussex timber yard now cover the fields.

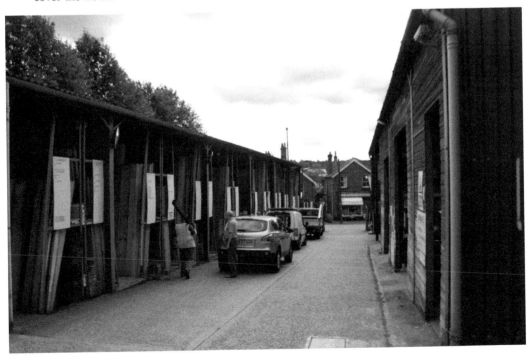

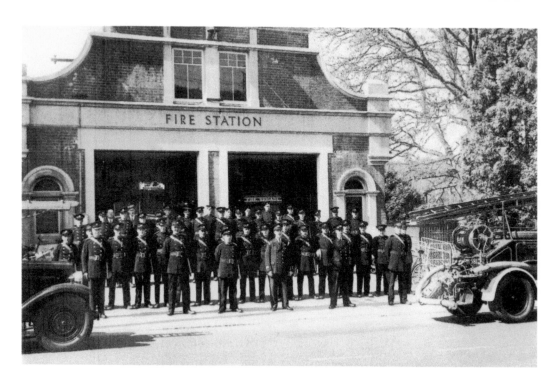

Haywards Heath Fire Station, 1940s

The town's fire station was once accommodated at The Yews, Boltro Road. In the early twentieth century, the fire brigade moved to premises in South Road (now demolished). In the 1960s there was another move to the modern premises in Mill Green Road (the old gasworks site) with its fire practice tower next to the railway embankment. Recently, this site was reorganised to house two services: West Sussex Fire & Rescue Service and the NHS South East Coast Ambulance Service. *Top: Cuckfield Museum.*

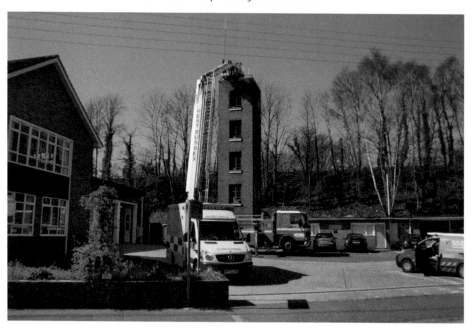

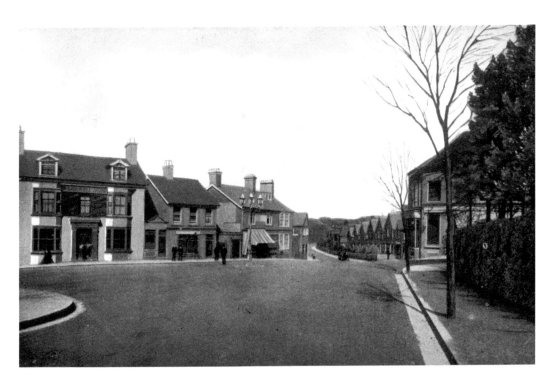

Commercial Square, c. 1910

This was an early retail hub near the station. The Burrell Arms pub on the left was named after a wealthy Cuckfield family, the Burrells, Sussex ironmasters. The building was redesigned in the 1920s and remains a popular venue. F. H. Beeny ran the noted 'emporium' on the right and claimed to offer the largest stock of groceries, wines, drapery, boots, clothing and furniture in the district. Beeny's is now several shops, although some have recently closed. *Top: Reproduced from an F. Frith & Co postcard.*

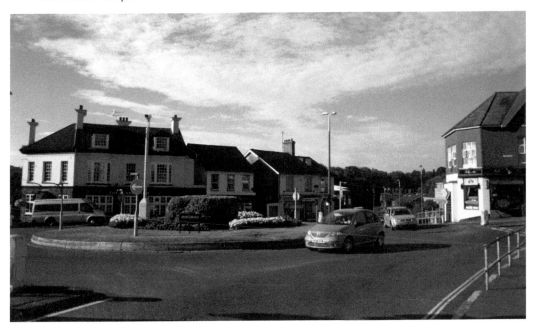

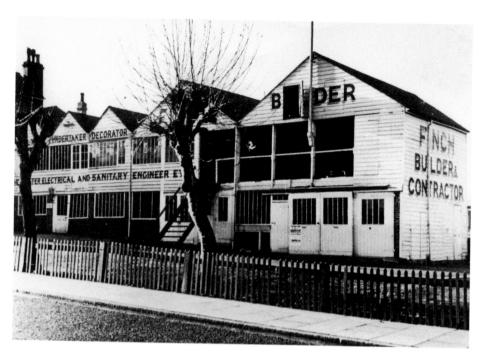

Jesse Finch Builder's Depot, c. 1912

Jesse Finch was another of Haywards Heath's 'founding fathers', who settled in the town from Horsted Keynes. His wide business interests included work as a building contractor, gas and electrical engineer, plumber, decorator, timber merchant, brickyard and pit sand quarry proprietor, and undertaker. Some of Finch's cast-iron drain covers survive *in situ*. The depot was demolished and replaced by the bus station in the 1950s. It is planned to replace this with a new Waitrose store as part of a station redevelopment scheme. *Top: Rogers Collection, West Sussex Record Office.*

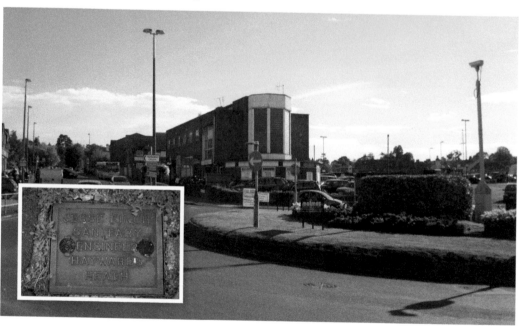

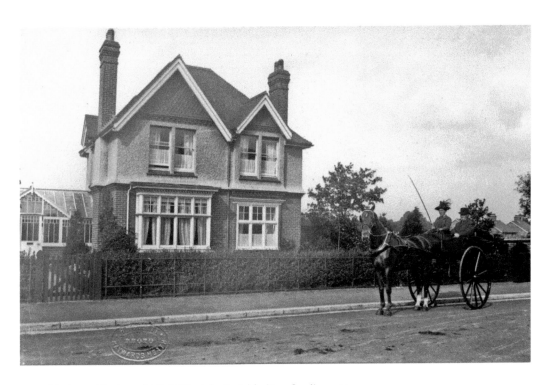

Mr Jesse Finch and His Wife Ada Outside 'Twyford', c. 1905

Jesse Finch played a considerable hand in developing Haywards Heath. Solid, practical Finch-built 'semis' line the western end of College Road and extend up Mill Green Road. Finch's also built larger dwellings, including some of the fine detached houses standing in Balcombe Road. He was also involved in the creation of the town's cricket ground, as mentioned. The house survives, just off Commercial Square, but motor cars have long-since replaced horse-drawn gigs. *Top: Rogers Collection, West Sussex Record Office.*

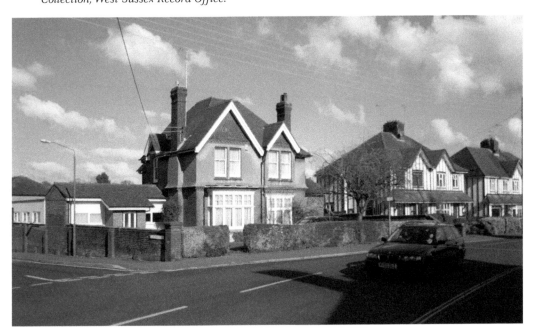

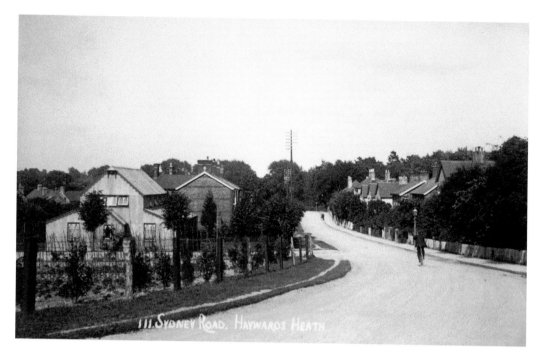

Sydney Road, c. 1911

Southlands Farm occupied this site. The old name is preserved by the modern apartment block Southlands Court, off Church Avenue. To meet the needs of an expanding local population, a licence was granted in 1897 by the Bishop of Chichester for the conducting of services and the building of a mission chapel. This prefabricated iron structure, known as the 'tin chapel', became the church of St Richard in 1916. The temporary building was replaced by the present brick-built church, consecrated in 1938.

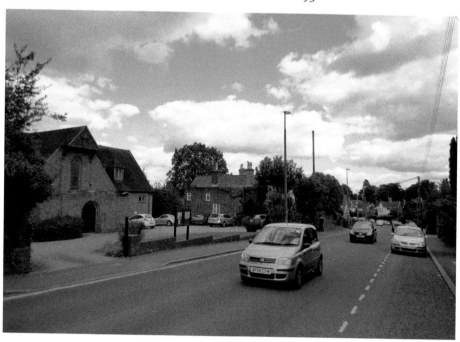

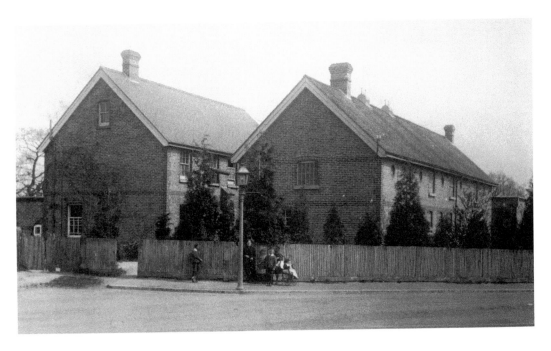

Thermogene Works, c. 1911

Haywards Heath, unlike its railway contemporary, the neighbouring town of Burgess Hill, is not normally associated with industry and factories. There was an exception, however, as the 1911 *Souvenir Guide* described: 'Haywards Heath is the British Home of Thermogene and the Works of this progressive undertaking are situated on the north-eastern corner of the town.' The old factory in Queens Road has long since been demolished, but Cuckfield Museum preserves an example of the product. *Inset: Cuckfield Museum.*

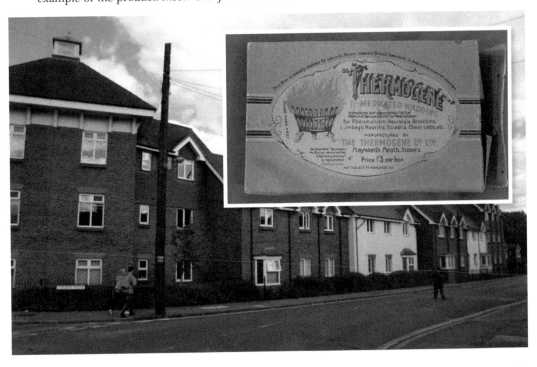

Scrase Bridge, *c.* 1905

This was one of the local features described on Mr Pannett's walk. The road leads to Lindfield but in the reverse direction travels south through Haywards Heath, up Oathall Road and into Franklyn Road via Sussex Square. Riders in the big event, the British Heart Foundation's annual London to Brighton bike ride, swept through Scrase Bridge on Sunday 17 June 2012.

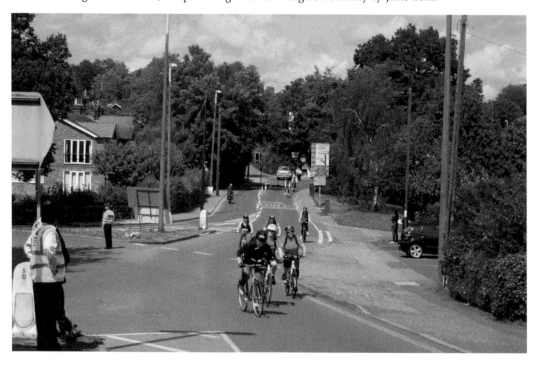

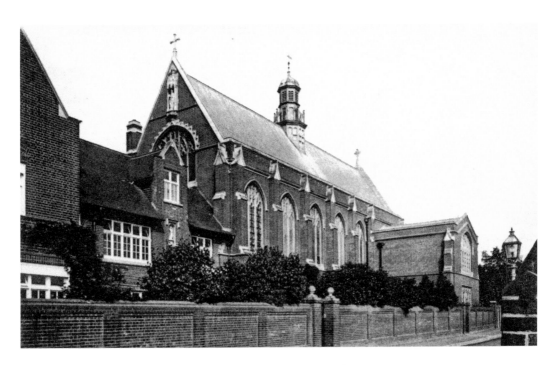

The Priory of Our Lady of Good Counsel, Franklyn Road, c. 1912

The priory was founded by the Canonesses Regular of St Augustine in 1886. The institution served the district's Roman Catholic community until St Paul's church was built on nearby land in Hazelgrove Road and opened for worship in 1930. The order declined from around the 1950s and the premises were sold in 1977. The chapel was ambitiously converted into a carvery restaurant (now closed) and achieved brief fame in 2007 when featured on the Channel 4 show *Ramsay's Kitchen Nightmares*.

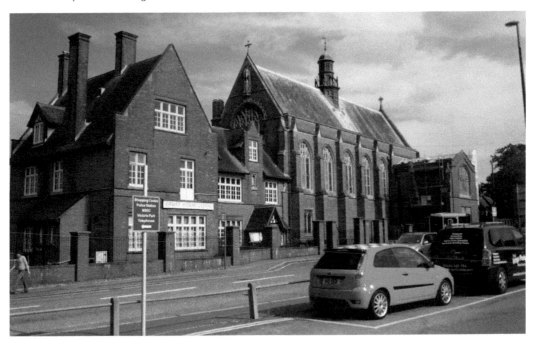

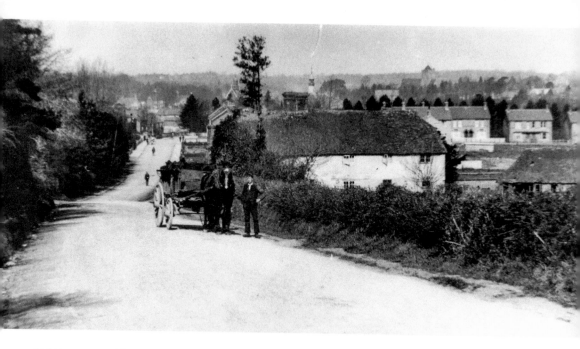

Old House, Franklyn Road, *c.* 1905
This was characterised by Mr Pannett as a local landmark. Before its demolition for the development of Dellney Avenue, Old House was inhabited by a character called William Botting, greengrocer, known as 'Fiddle' Botting. He hawked fruit, vegetables and popcorn around town in a pram. 'Fiddle' also had a Tuesday pitch at the market. The priory is visible in the distance. Mr Pannett mentioned that a long vanished pub, the Red Lion, had once stood near its walls.

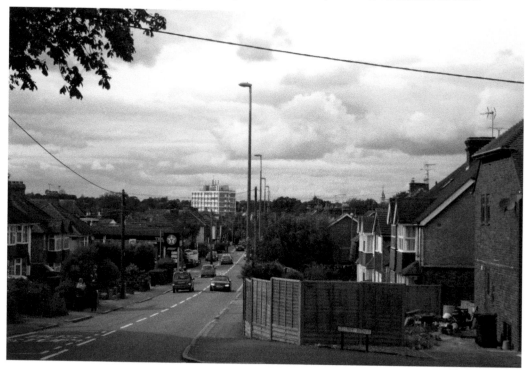

Asylum Lane, c. 1914

Franklyn Road leads to a sharp right turn into the present Colwell Road. Modern housing lines the road to the right. Early last century this was leafy Asylum Lane, also known as Asylum Road, giving access to and originally named after one of the most important buildings in the county, the Sussex Lunatic Asylum. This pioneering institution, which opened in 1859, was deliberately sited at Haywards Heath because of the town's excellent railway and the district's healthy environment.

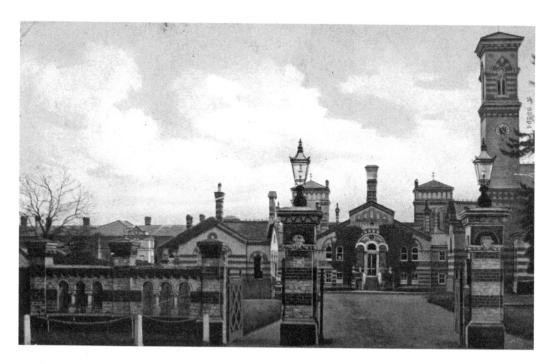

Brighton County Borough Asylum, c. 1910

Clarke's Directory of 1883 gave the town's population as 1,814. 'If the inmates of the Asylum and the houses immediately adjoining the district were taken into calculation, the population would number between 3,000 and 4,000 persons.' In 1903, the Sussex Asylum was reorganised as the Brighton County Borough Asylum. Following the introduction of the NHS in 1948, the institution was renamed St Francis Hospital. Changes in health provision resulted in the hospital's closure in 1995 and the conversion of the massive structure into apartments.

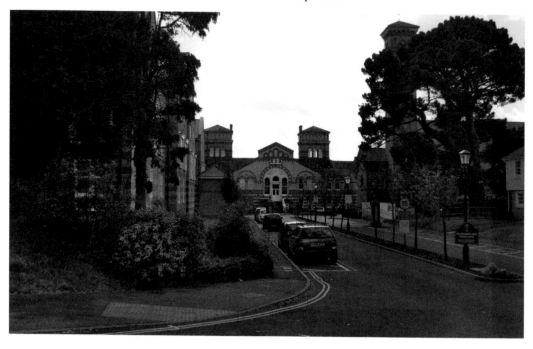

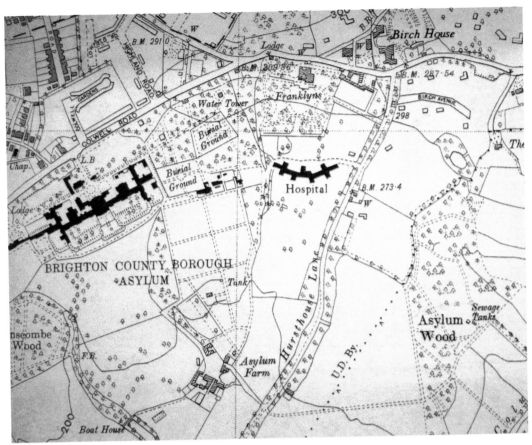

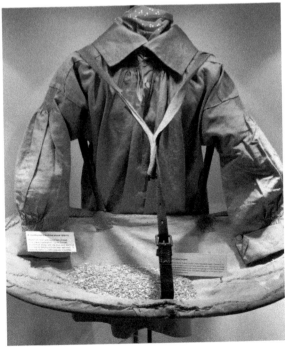

Ordnance Survey Map of the
Asylum and Asylum Farm, 1909,
and Seed Hopper Used on the Farm,
Probably 1880–1900.

The story of the asylum and the
St Francis Hospital is told in James
Gardner's book, *Sweet Bells Jangled
Out of Tune*. The institution was
technically in Wivelsfield Parish
when it was founded, in contrast to
the rest of Haywards Heath, which
fell mainly in Cuckfield and Lindfield
Parishes. The asylum was so vast
that it had its own farm. 'Lunacy'
or mental illness was very poorly
understood by the Victorians, but
part of the treatment was to keep
inmates occupied and even put them
to work. *Top: West Sussex Record
Office; bottom: Cuckfield Museum.*

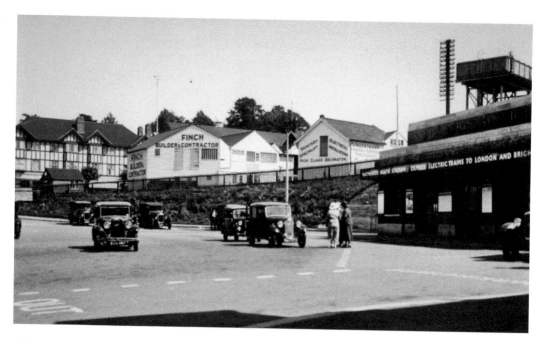

Railway Station Forecourt, c. 1934

Haywards Heath was again at the forefront of railway development in 1933 when electric services arrived. Faster, cleaner and more reliable trains were welcomed but there was a penalty – the 'third rail' system proved susceptible to icing up in freezing weather. The station was upgraded and the main entrance moved around from Market Place to the present position. Finch's depot is visible in the old view. In contrast to today, the forecourt coped with the relatively limited numbers of cars.

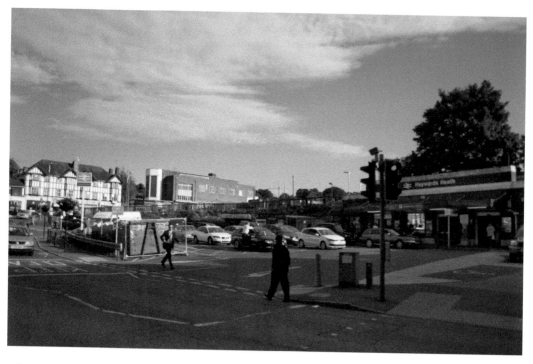

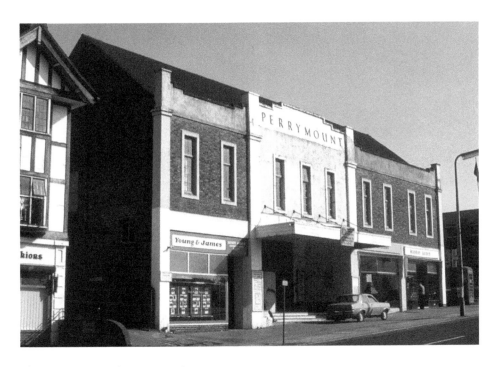

The Perrymount Cinema, c. 1984

The Commercial Square area benefitted from the station's upgrade. A new cinema, the Perrymount, named after the road in which it stood, opened in 1936. It seated 800 and included a café-restaurant and dance hall. Together with the slightly older Broadway cinema, the Perrymount benefited from a post-war increase in cinema attendance, but as other forms of entertainment became popular its takings declined and it closed in November 1972. The site is now covered by the car park and an entrance to offices.

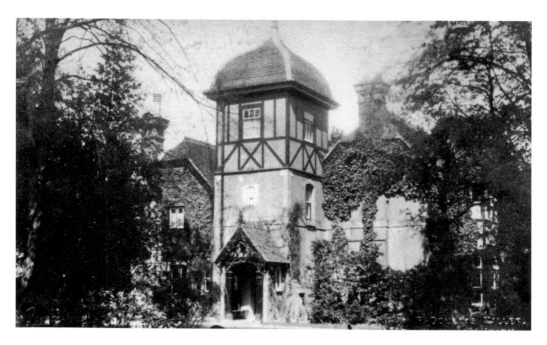

St Clair, *c.* 1912

Haywards Heath is relatively well provided with schools, both private and state. This Tudor-Gothic-style residence was St Clair, one of the town's private schools, established by Miss Stevens in the 1930s. It existed until the late 1960s when it closed down and was subsequently demolished. When the site was redeveloped, Clair Hall, the new community centre that replaced the Sussex Hall, adopted the old name. Other successful private schools surviving only in name are Sharrow (Sharrow Court) and Trevelyan (Trevelyan Place).

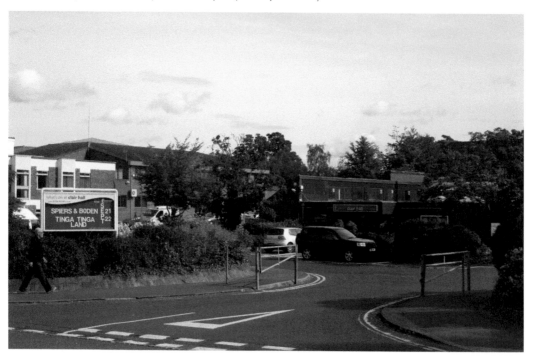

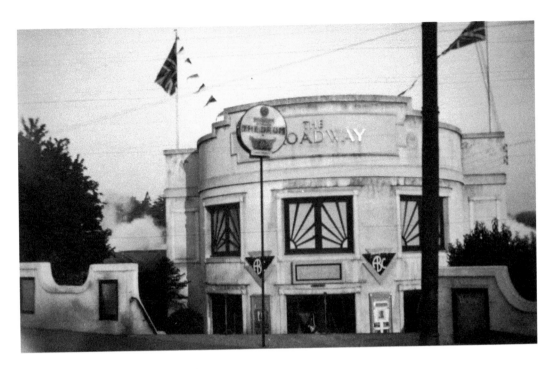

The Broadway Cinema, 1938

The town's second cinema, named after the Broadway, opened in 1932. It had an unusual sloping site backing on to the Victorian railway cutting. It was reached by going down a flight of steps. The cinema seated 725 and was eclipsed by the newer Perrymount. It appears not to have been profitable and closed in 1952. The premises were used by Uptons as a furniture showroom in the 1960s. The building was demolished in 1987. Rockwood House now stands on the site.

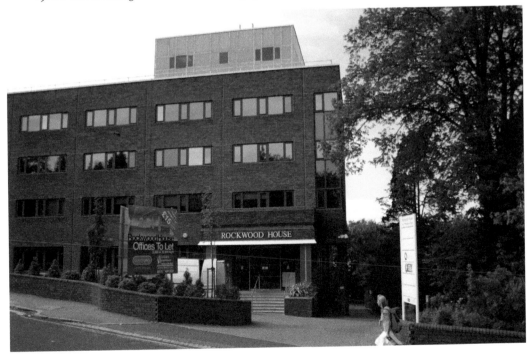

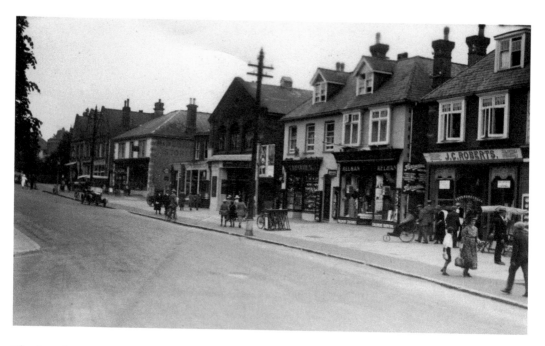

The Broadway, c. 1932

The Broadway rivalled Market Place, Commercial Square and, on the other side of the railway cutting, Boltro Road. This photograph shows the town's first cinema, the Heath, in the centre. The Heath seated 400 but was too small to remain viable. It closed after the opening of the Perrymount in 1936. The building was replaced with a more modern design topped with a distinctive spire. It was once a gas showroom and is now a restaurant and newsagent. Sadly, the town presently lacks a cinema.

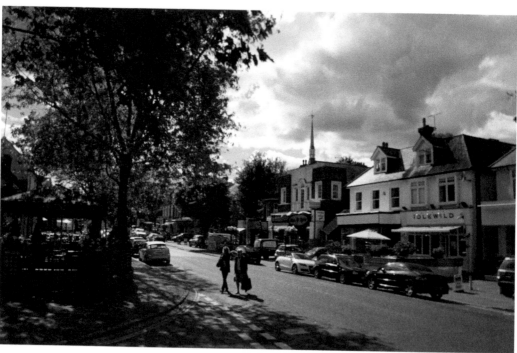

Haywards Heath Building Society Premises, c. 1989

This is one of Haywards Heath's success stories. The building was the head office of the Haywards Heath Building Society (founded 1890) from 1938 to 1989. The society eventually moved to more spacious offices in Boltro Road and the Broadway premises were converted into the present café. The Broadway rapidly became a 'restaurant capital'. The society was absorbed by the Yorkshire Building Society, which maintains its traditions, and the Broadway restaurants thrive.

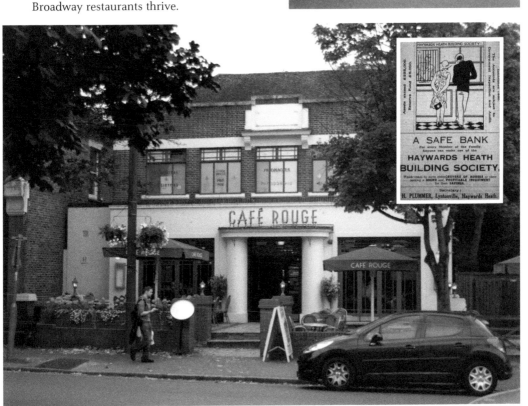

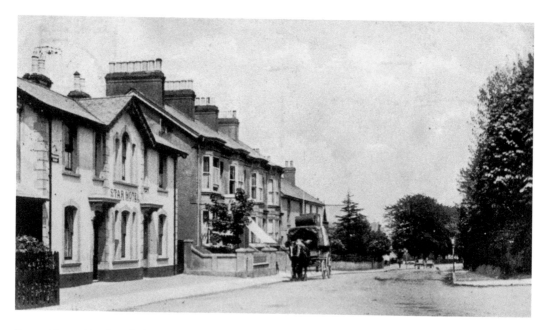

Perry Mount Road and the Star, *c.* 1900

In the early twentieth century this was said to be the busiest part of town, especially on school days due to the proximity of the St Wilfred's church schools. Development was checked to a large extent by the presence of a grand house, Clevelands, and its extensive grounds adjoining Muster Green. The Broadway, as it became known, remained undeveloped on the east side until the 1920s. An electricity showroom was built on the right, now the Business Centre. The Star remains a popular pub.

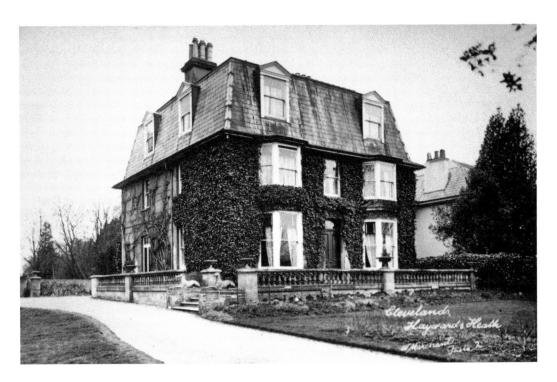

Clevelands, *c.* 1910

Clevelands was probably the first Haywards Heath residence built as a direct result of the railway, sited on the top of Muster Green tunnel. It was the home of Mr Flesher, the contractor responsible for the driving the railway through the district. The building was demolished and replaced by the present Muster Court apartment block in the late 1950s. These apartments overlook the great Victorian railway cutting to the south and, as mentioned, a circular brick ventilating tower stands in the grounds.

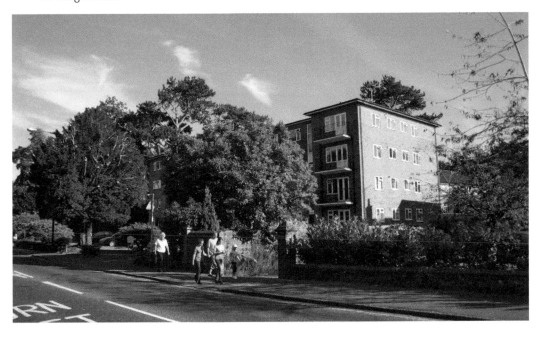

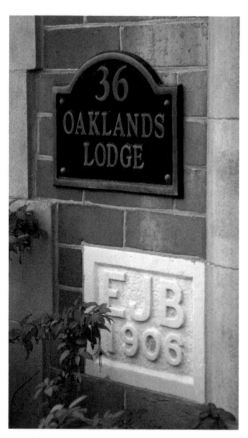

Oaklands, 1906
Haywards Heath's 'salubrious' surroundings made it popular with Brighton businessmen. Mr Harry Treacher, a Brighton bookseller, built a grand mansion called Oaklands. Sir James Bradford, also from Brighton, who had made his money in the railway business, bought Oaklands. He philanthropically endowed the Bradford Almshouses, opposite Beech Hurst. After his death in 1930, Oaklands became local government offices: firstly Cuckfield Urban District Council and subsequently Mid Sussex District Council. The initials 'E. J. B.' on Oaklands Lodge are those of Sir Harry's wife, Emma Jane Bradford.

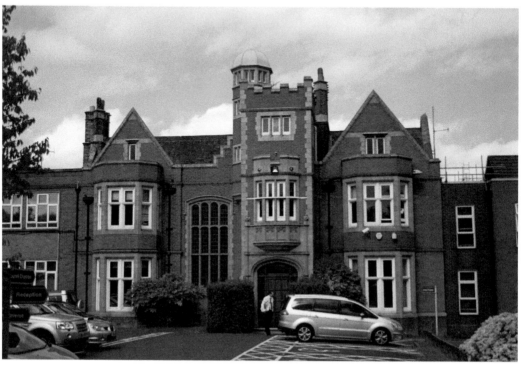

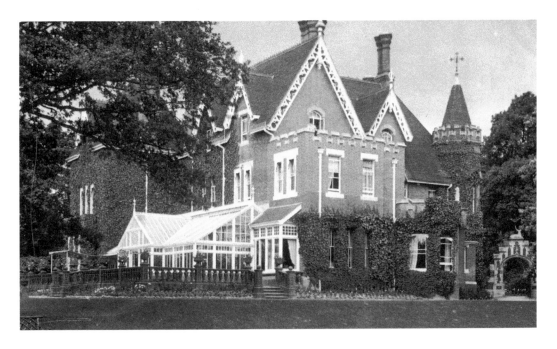

Beech Hurst, 1908

Beech Hurst and its beautiful gardens, formerly the residence of Mr W. J. Yapp, were gifted to the town. The house, which had been a hospital annexe in the First World War, was demolished in the early 1950s and replaced with a quadrangular brick shelter. A Harvester restaurant was added recently. The miniature railway is nationally famous. Beech Hurst was a fitting venue for the 'Once in a Lifetime' event celebrating the Queen's Diamond Jubilee on 4 June 2012.

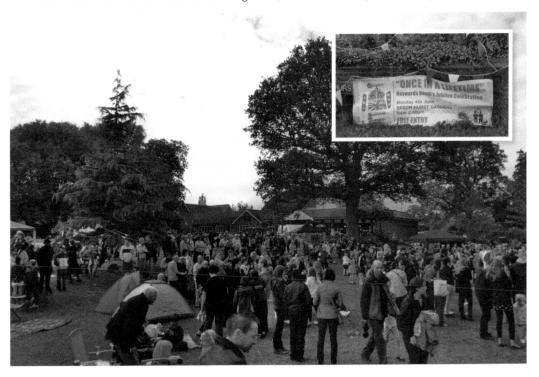

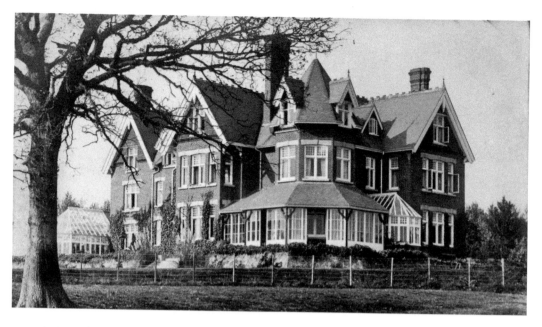

Oakwood, 1911

Another of Haywards Heath's large mansions was Oakwood, just south of Muster Green. Today the site consists of sheltered housing for the elderly and a care home, but early last century the England family rented the big house. Their son, E. Gordon England, was truly one of those 'magnificent men in their flying machines'. He and fellow aviators, such as Howard Pixton, occasionally made flying visits to the family home, sometimes running out of petrol or crashing *en route* but without serious harm.

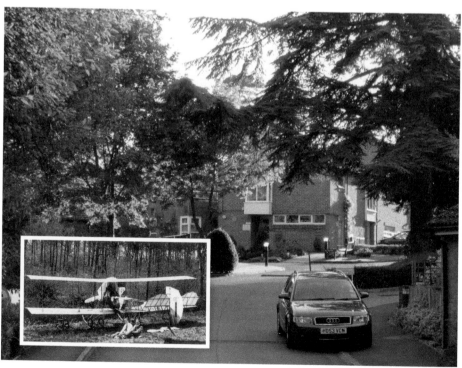

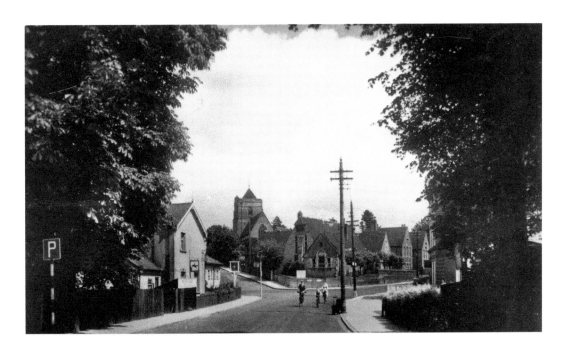

St Wilfrid's Church, *c.* 1908

Haywards Heath's parish church was a relative latecomer. Church services had been held in a carpenter's premises near the station. The railway arrived in 1841; the huge asylum opened in 1859; St Wilfrid's school opened in 1857. The church building, designed by G. F. Bodley in traditional 'Sussex' style and dedicated to St Wilfrid, was finally consecrated in 1865 and came to signify the actual centre of the town. The town sign, commemorating the Battle of Haywards Heath, stands in front of the old school, now Zizzis. *Top: Reproduced from an F. Frith & Co. postcard.*

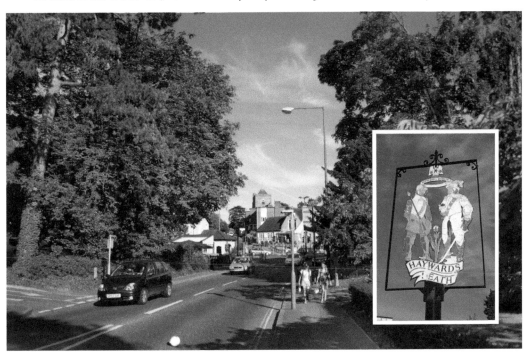

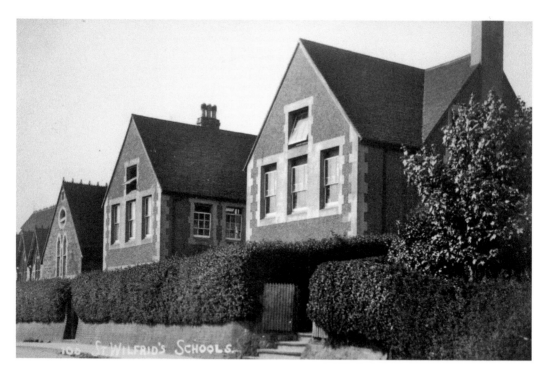

St Wilfrid's Church Schools, *c.* 1908

The old church school buildings became redundant in the 1950s. Part of the site was redeveloped for shops. The western section became a Christian Science reading room, later adopted by Zizzis. A new state infant school was built in New England Road, now called Warden Park School, and a church school for infants was built in Eastern Road. Additional council school accommodation had been opened in South Road in 1907 and replaced by a new school at Scrase Bridge in 1938, now Oathall Community College.

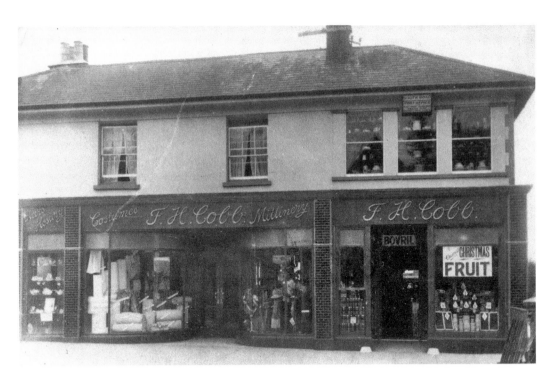

Cobb's Store, South Road, Early Twentieth Century

Cobb's, adjacent to Victoria Park, was typical of the kind of small, traditional local business that sold provisions and other essentials in the era before modern chain stores and supermarkets appeared. Beeny's traded in Commercial Square, the Mid Sussex Stores in the Broadway, the International Stores and Cobb's in South Road. Gloves, hosiery, costumes, millinery, Bovril and 'choicest Christmas fruits' are advertised. Mr Pannett mentioned that an old farmhouse used to stand here in the old days. *Top: Rogers Collection, West Sussex Record Office.*

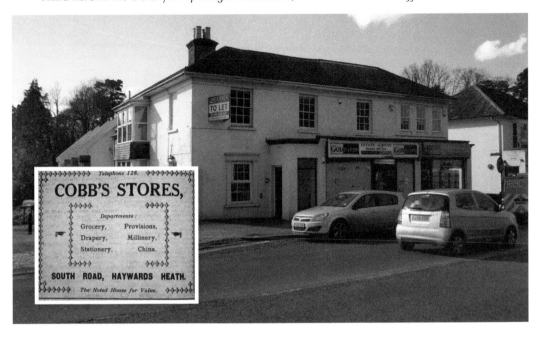

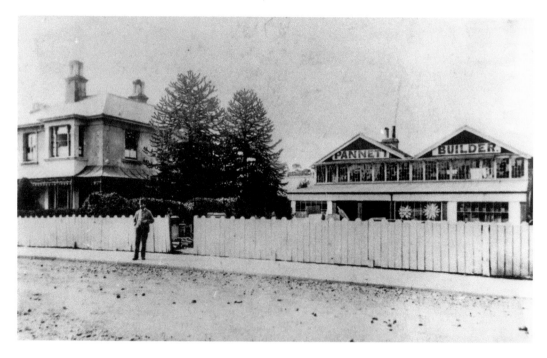

Mr Richard Pannett Standing Outside His House in Church Road, 1860s

North of Cobbs, on the other side of the churchyard, Richard Pannett had his house, Highland House, which still stands, and his builders' yard, long since redeveloped. Richard Pannett built many of Haywards Heath's houses, including some fine properties along Muster Green South. His son, Arthur, became a local architect and the describer of the imaginary walk occasionally cited in this account. He recounted that long ago a windmill stood near here. The miller's rent included payment of a cockerel!

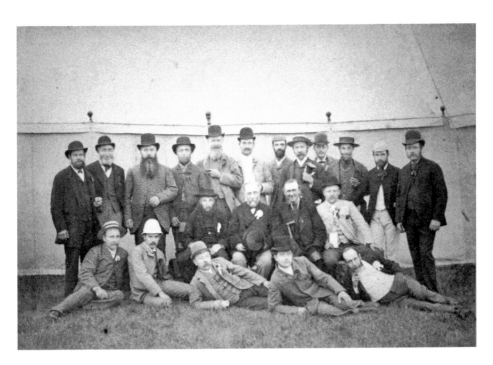

The Haywards Heath Horticultural Society Committee, *c.* 1889
Although faded, this scene in 'Pannett's meadow' clearly portrays the first vicar of St Wilfrid's, the Revd T. G. Wyatt – the treasurer, seated on the left of the middle row. Arthur Pannett, the narrator of the walk through old Haywards Heath, stands in the back row, second from the right. He sold the meadow to the council, which created Victoria Park in commemoration of Queen Victoria's Jubilee in 1897. The park is appreciated today as one of the town's greatest and most attractive assets.

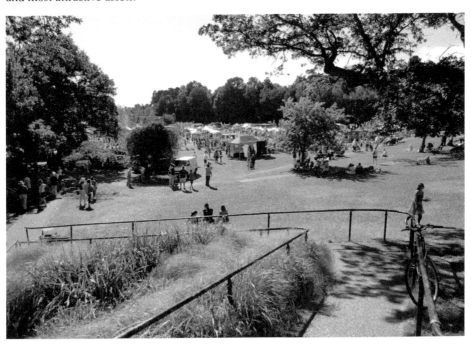

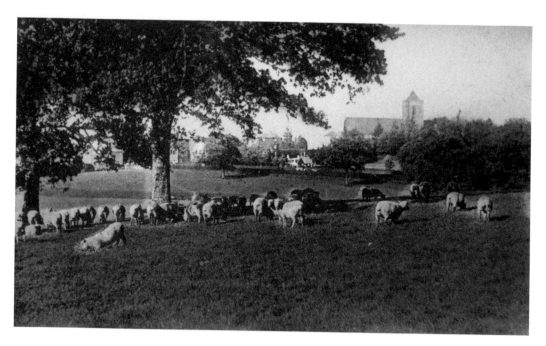

Victoria Park and St Wilfrid's Church, *c.* 1910

The practice of grazing sheep in the park seems to have persisted into the twentieth century. This is one of Haywards Heath's finest views, looking north to the church. The view southwards from the church across the park is equally scenic and extends to the South Downs in the distance. The annual Haywards Heath Town Day 2012 was very well supported, with many amusements, activities and stalls. Victoria Park is the accepted venue for many events, including football matches, in contrast to the genteel recreation ground.

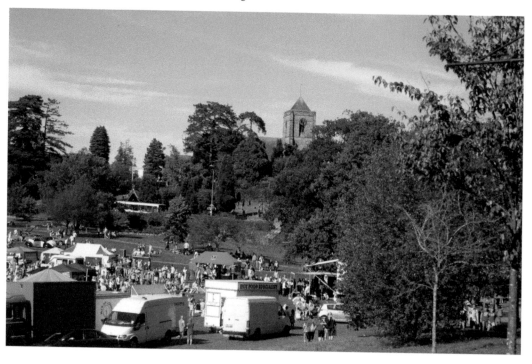

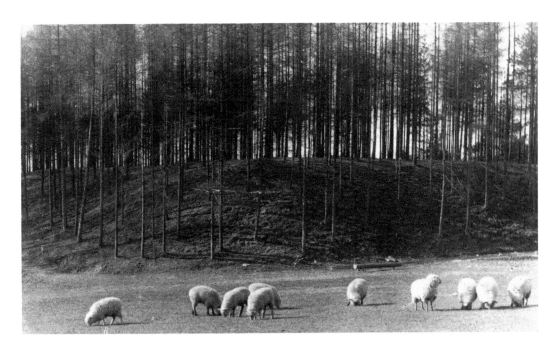

Victoria Park and the Plantation, *c.* 1910

Not much has changed for many residents and commuters since the sender of this card scribbled '...8.55 a.m. – just off for the City'. The 'planny' is earth excavated by the railway in 1841, planted with trees. Some of the railway spoil was also deposited on Muster Green. The Town Twinning Association had a stall on Town Day 2012. The year had a celebratory feel locally, with the earlier 'Once in a Lifetime' event at Beech Hurst and national success at the London Olympics.

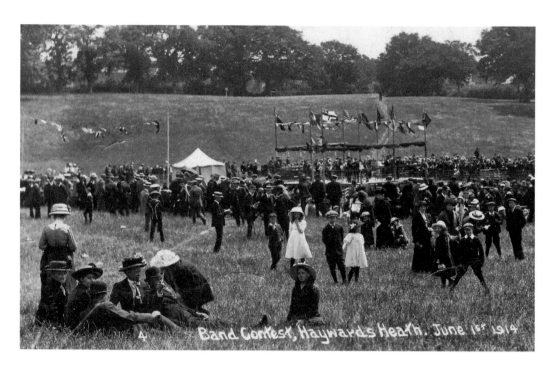

Band Contest, Victoria Park, 1914

One of the contenders in 1914 is likely to have been the Haywards Heath Brotherhood Brass & Reed Band. This band was founded in the 1880s with the blessing of a local Methodist chapel. In 1986, this band's descendant, Haywards Heath Town Band, amalgamated with the Burgess Hill Brass Band to form the Mid Sussex Brass Band. At the 2012 Town Day, the Great Karaoke Competition was a very different event.

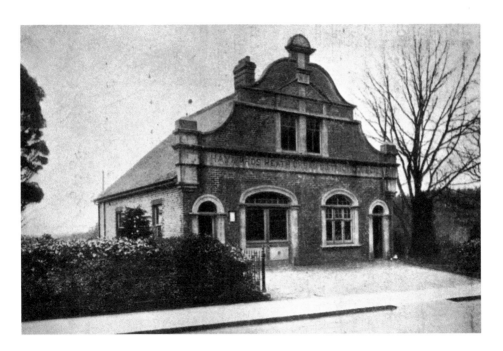

Haywards Heath Urban District Council, 1911

This historic building, immediately east of Victoria Park, was built to house the offices of the relatively short-lived Haywards Heath Urban District Council. This authority disappeared with the creation of Cuckfield Urban District Council, based at Oaklands and jointly administering Haywards Heath, Cuckfield and Lindfield. Populous Haywards Heath seemed to 'disappear' under the reorganisation, but this was simply a case of ancient Cuckfield reasserting itself as 'senior partner' in the triumvirate. Haywards Heath finally gained a Town Hall in Boltro Road in 1990 but with lesser powers. *Top:* Souvenir Guide *1911, West Sussex Record Office.*

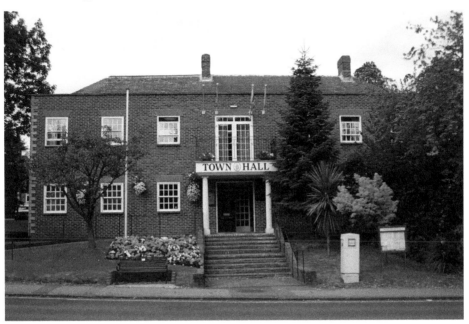

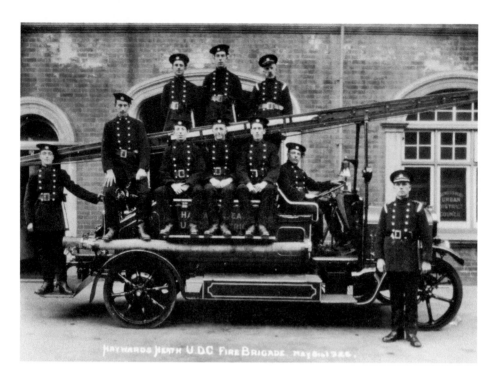

Haywards Heath Fire Brigade, 1924

The same building is seen here in close-up some thirteen years later. This reveals its dual function – it does not only contain offices but also a fire station. In fact, it was the fire station function that took over on the demise of the old urban council. The fire service moved out to new premises in Mill Road, as described. The building itself languished for some years, like the old Boltro Road police station, but was eventually demolished and replaced with new shops and offices.

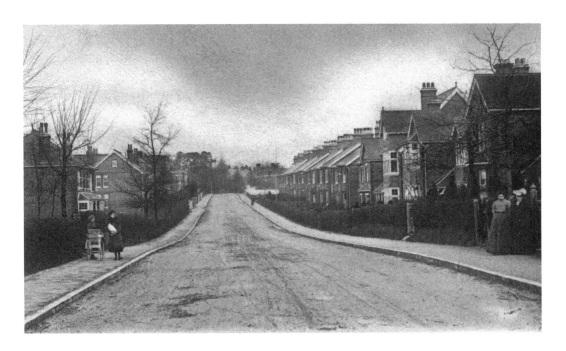

Little Haywards Road, *c.* 1904

This turning, running south from the mid-point of South Road, was described by Mr Pannett as an old cart track running to Little Haywards Farm. He also mentioned that as tracks developed into roads, flints from the Downs were the only surfacing material. The road became built up from around the 1880s and rows of solid, respectable medium-sized semi-detached houses appeared. Apparently, the residents objected to being 'little' and the initial epithet was dropped, despite the road's history.

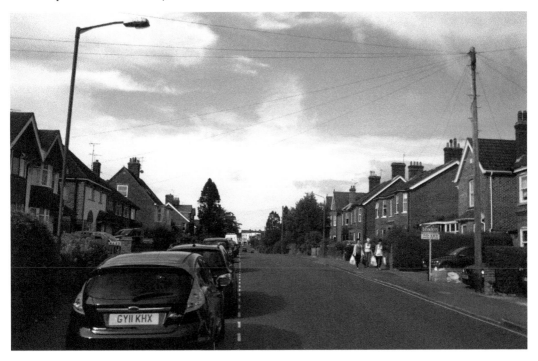

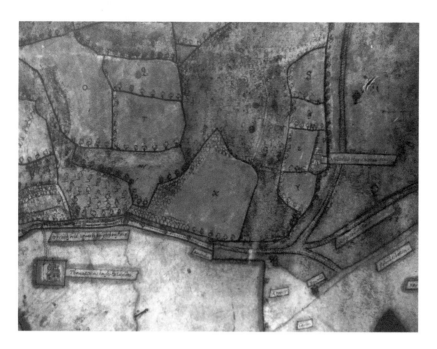

Little Haywards Farm, 1638

The farm that gave its name to the road survives as a private dwelling, if much obscured by recent development. In 1638, this late medieval hall house was owned by Nicholas Hardham, as described at the beginning of the narrative. Here the 1638 map shows the house and what developed into the present junction of Haywards Road with Ashenground Road. The route to 'Cuckfielde, Lewes and Brighthemstone' is marked. It proceeded west through the present Ashenground Woods (not shown). *Top: 1638 Map, West Sussex Record Office Add MS 28,784/Sussex Archaeological Society.*

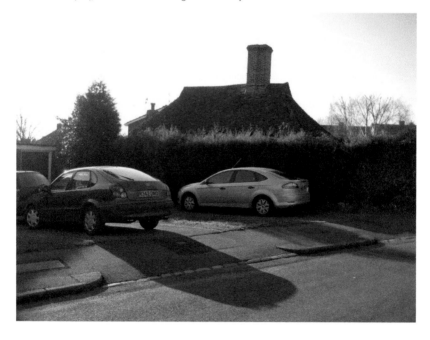

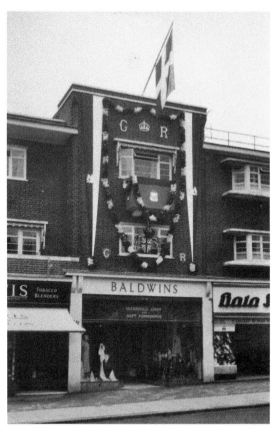

Baldwins Shop Decorated for King George V's Jubilee, 1935
Returning up Haywards Road and into South Road, a parade of 1930s shops is situated opposite. Baldwins haberdasher's is one of Haywards Heath's great survivors as a small family business. The business offers a traditional, personal shopping experience. Lewis tobacconist's and Bata shoes were adjacent. On the nearby side-wall of an off-licence (closed) is a Latinised marker stone, I. B. S. (J. B. S.) that was placed by Sainsbury's. The company developed the area in the mid-1930s. Nearby Betfred now occupies the original Sainsbury's three-storey premises.

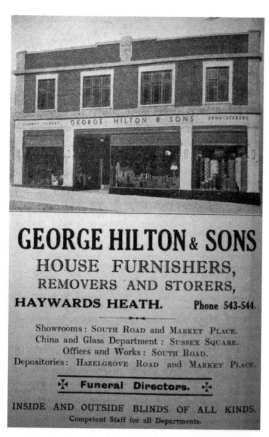

GEORGE HILTON & SONS

HOUSE FURNISHERS,
REMOVERS AND STORERS,

HAYWARDS HEATH. Phone 543-544.

Showrooms: SOUTH ROAD and MARKET PLACE.
China and Glass Department : SUSSEX SQUARE.
Offices and Works : SOUTH ROAD.
Depositories: HAZELGROVE ROAD and MARKET PLACE.

✠ **Funeral Directors.** ✠

INSIDE AND OUTSIDE BLINDS OF ALL KINDS.
Competent Staff for all Departments.

George Hilton & Sons, 1930s

Further east in South Road, George Hilton & Sons was a large local business that flourished but, unlike Baldwins, did not survive. Hilton's occupied a more modest Victorian building on this site from 1888. The firm's success was symbolised by the modernised premises designed by the eminent local architect, Harold Turner. The 1932 premises were demolished in the 1980s and Hilton's was incorporated into the new Orchards shopping centre as a prestigious department store. Hilton's experienced business difficulties and ceased trading in 1987. *Top:* Mid Sussex Directory *1940, Cuckfield Museum.*

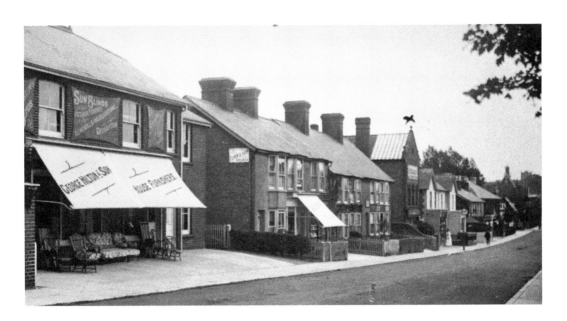

Hilton's Second Premises, 1914

This shows Hilton's 'No. 2 door' before modernisation. South Road evolved into Haywards Heath's main shopping district. Residential at first, dwellings were converted to shops as population and trade increased. Large-scale redevelopment occurred in the 1930s, coinciding with the introduction of electric train services, a relative economic boom in the south-east, rising home ownership and increased consumerism. In the subsequent boom of the 1960s, bigger stores were built in new materials. The twenty-first century brought more change: charity shops, coffee shops and, unwelcome to some, a pound store.

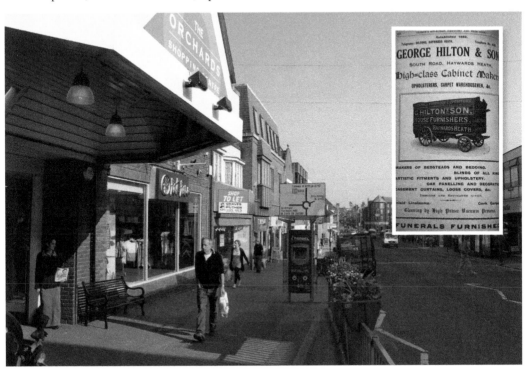

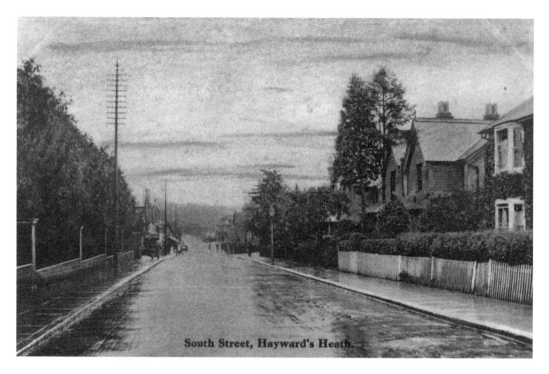

South Street, Hayward's Heath.

South Street, Haywards Heath, c. 1904

Apart from the vivid sunrise, this easterly view of South Road, or 'South Street, Hayward's Heath', really emphasises the district's early residential character. The left side appears to be completely undeveloped. The spelling is interesting. Is it a 'street' or a 'road' at this point? The apostrophe is fascinating too, seeming again to link the town to the legendary 'Hayward'. The earliest recorded version of the name was simply 'Hayworth', meaning 'the hedge or hay enclosure' on the heath (Glover, 1997).

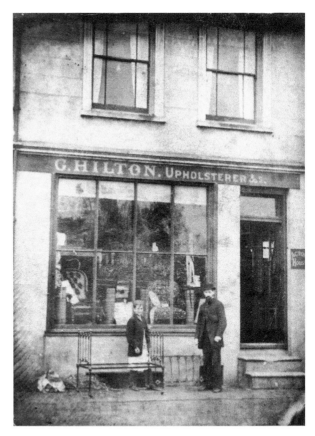

George Hilton's First Shop, Acton House, *c.* 1882

To conclude the George Hilton story, he arrived in town in 1882, 'a single man with a box of tools and a very small capital'. His first shop appears to have been in this locality before moving west along South Road: 'I opened No. 1 door for business at the Crossways...' Mr Hilton was born in 1855 at Folkington, East Sussex, and started working life as a shepherd boy on the South Downs. The *Mid Sussex Times* premises were originally in Boltro Road, founded by Mr Charles Clarke in 1881.

Top: Rogers Collection and Add MS 54798 and 54801, West Sussex Record Office.

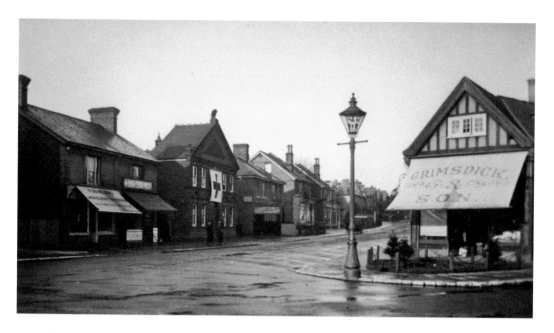

Cross Roads Haywards Heath, *c.* 1904

Mr Hilton referred to this as 'the Crossways'; it is also known as Sussex Square. The premises around Sussex Hall (banner-draped, perhaps for hospital fundraising) at the eastern end of South Road were then regarded as the district's prime business sites. The hall was acquired in 1889 and became a busy venue for theatre, pantomime and public debates, including the sometimes contentious 'Haywards Heath Parliament'. Some residents thought that the 99p Store, which opened on the left in 2012, was bad for the town's image. *Inset: Mid Sussex Directory 1930, Cuckfield Museum.*

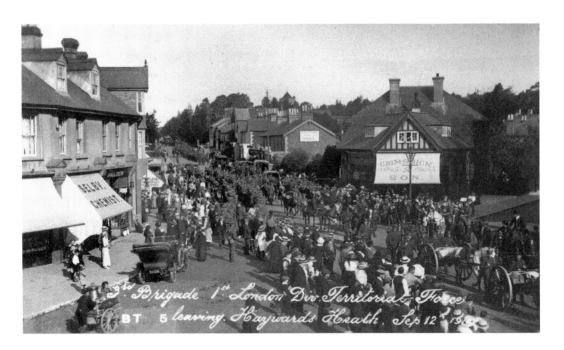

In the photograph: *3rd Brigade 1st London Div. Territorial Force leaving Hayward's Heath. Sep 12th 19...* / *BT 5* / SELBY CHEMIST / GRIMSDICK SON

3rd Brigade 1st London Division Territorial Force Leaving Haywards Heath, 12 September 1914
This evocative picture of the Cross Roads on another occasion, taken by the well-known local photographer Bertram Tugwell, not only captures the big event but also conveys a wealth of detail: the troops' uniforms and equipment, the manner and dress of the large crowd of well-wishers and some of the local shops, especially Selby's chemist's and Grimsdick's. Thousands of soldiers marched through the town to reach military encampments or to embark from Newhaven for the war in France.

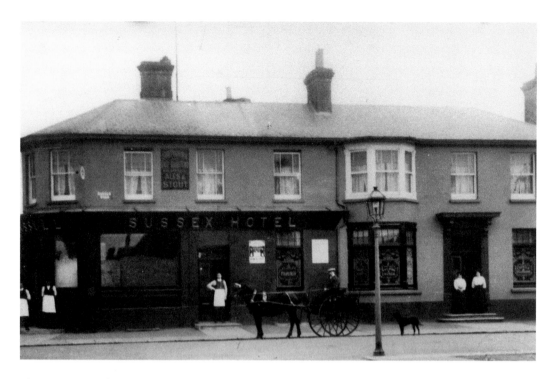

The Sussex Hotel, *c.* 1900

The previous photograph of the Territorials was taken from an upper window of the Sussex (formerly the Volunteer, built in 1860). The pub closed in 2003, but it played an historic role in Haywards Heath's development as a meeting place for local groups before the opening of the public hall. An example was the Haywards Heath & Wivelsfield Conservative Association. In the 1880s, the publican was the aptly named Jacob Grist, who was also a farmer. His gravestone can be seen in St Wifrid's churchyard, opposite the west door. *Top: Rogers Collection, West Sussex Record Office.*

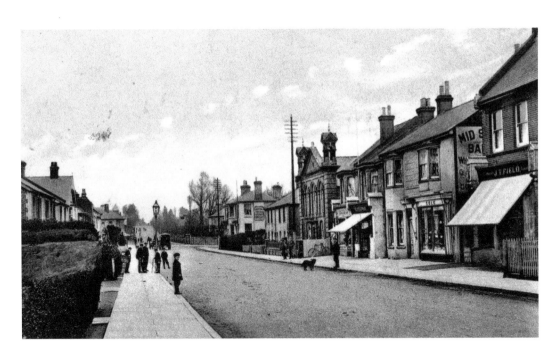

Sussex Road, c. 1910

Another of the town's shopping areas that did not achieve South Road's 'upmarket' reputation. Large paving slabs are clearly visible. Superstitious folk believed that it was 'unlucky' to tread on the cracks. Mr Hilton was a patron of the Brotherhood Band, which practised behind the old Methodist (formerly Brotherhood) chapel on the right. The chapel's façade was altered in the 1950s. The present view shows Haywards Heath's one and only high-rise block, built in the 1960s.

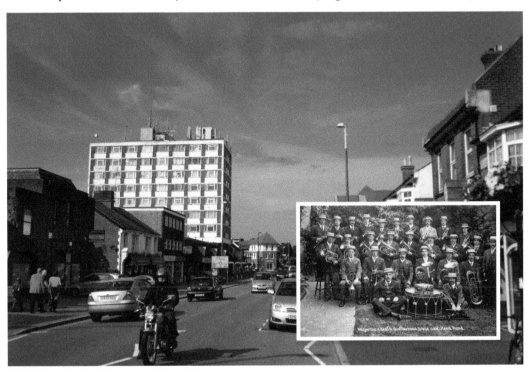

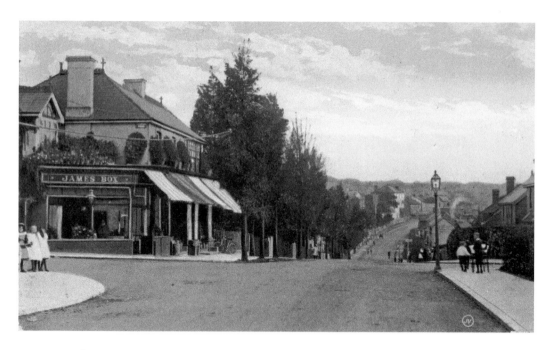

Sussex Road, 1911

Mr Box owned other shops, including a butcher's in Mill Green Road. Out of the picture, on the left, is the aptly named Heath pub, formerly the Triangle, named after Triangle Road, which turns sharply to the left. The right turn opposite, Ashenground Road, leads to Ashenground Woods, across the railway at Ashenground Bridge. The old hospital was situated halfway down on the right until 1912. In 1914, detachments of troops marched along this undulating route to Wivelsfield and the encampments and ports beyond. *Inset:* Mid Sussex Directory *1930, Cuckfield Museum.*

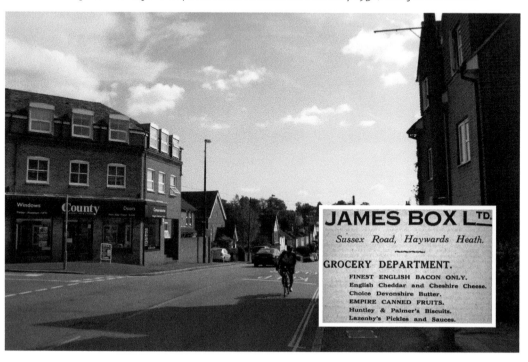

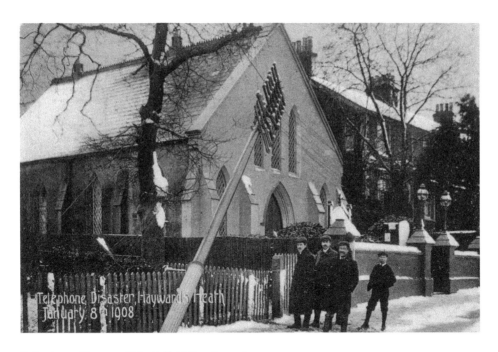

Telephone Disaster, Wivelsfield Road, 1908

The railway was not the only engineering marvel that stimulated the development of Haywards Heath. The electric telegraph was introduced at about the same time, and by the early twentieth century the telephone was operational too. It was considered a local disaster when a snap of severe ice brought down many telephone cables. The old Congregational chapel became St Edmund's church, serving the area until 1966 when the premises became a scout hut. The Mid Sussex Islamic Centre & Mosque was founded here in 2010.

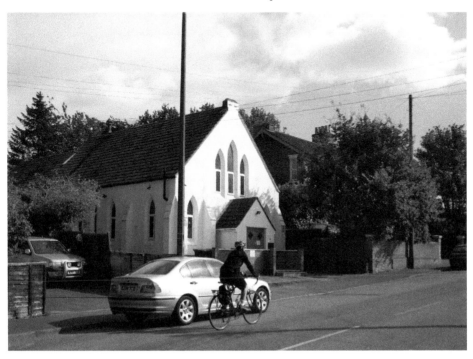

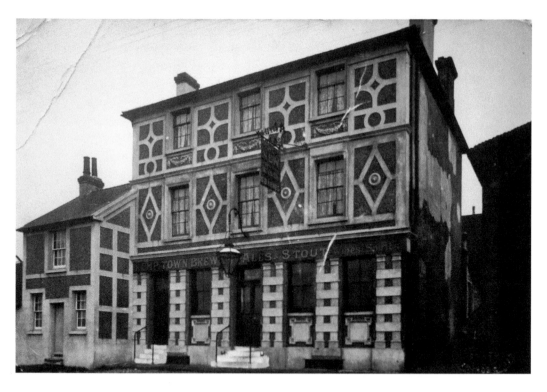

The New Inn, Wivelsfield Road, *c.* 1910

Many of Haywards Heath's nineteenth-century pubs have been lost in recent years under redevelopment pressures, dips in the economy and changing lifestyles. The New Inn, later known as the Ugly Duckling and the Duck, finally succumbed in 2009, and the site was redeveloped. A Sainsbury's local store and Pet Corner replaced the old pub. Perhaps the troops were allowed a refreshment stop in 1914 as they left Haywards Heath on their long march south to the coast.

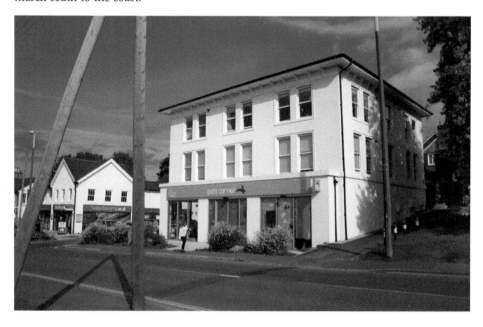

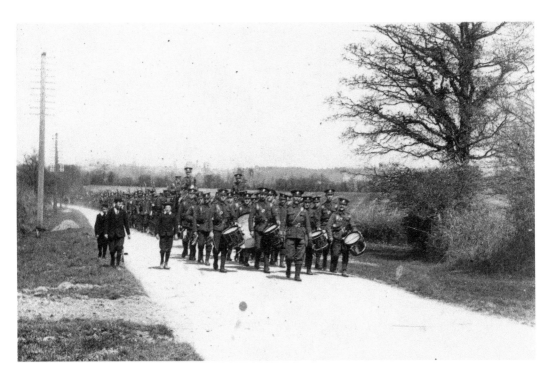

Territorials Marching to North Common, 1914

This detachment of troops has almost reached Wivelsfield. It is not clear which regiment. They make a brave site with their drums, impressing local youths who march alongside. The great façade of the Haywards Heath's County Asylum, built on farming land, is faintly visible in the distance. It was actually situated in the north of Wivelsfield parish. It is difficult to imagine such a scene on today's busy road and perhaps naturally poses the question – how many of these soldiers returned from France?

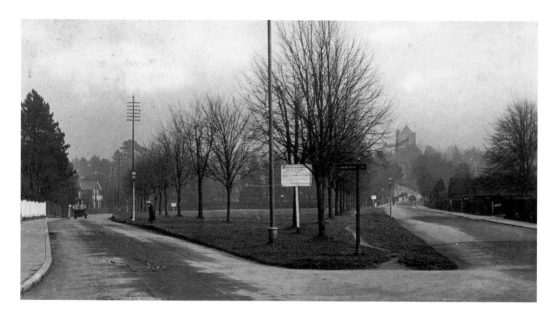

Muster Green, 1911

Haywards Heath paid a heavy price in the First World War: '166 men are named on the Memorial in the Parish Church ... and the Memorial Stone on Muster Green'. The stone, a simple granite monolith from Penryn, Cornwall, engraved 'In Memoriam 1914–1919', was unveiled by Lord Leconfield in 1924. Following the Second World War a further ninety-two names were added. The card's message reads, 'This is where the soldiers drill and play football, they've taken most of the grass off it...' The second picture shows the scene on Remembrance Sunday, 11 November 2012.

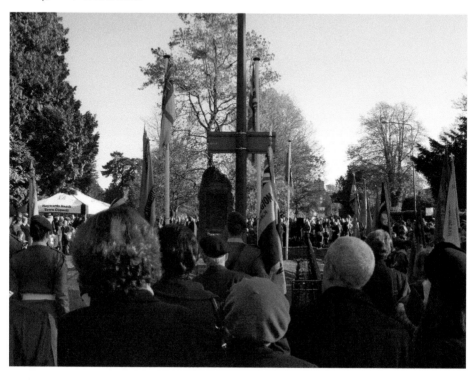

Haywards Heath Grammar School Building, 1980s

Haywards Grammar school opened on the Harlands Farm site in 1958 under Mr Jarvis's headship. The school motto was '*Usque Conabor*' ('I shall try my uttermost'). Many of the first pupils came from Scrase Bridge School, where a grammar 'stream' had been introduced in 1956. The site is now Sixth Form Haywards Heath, part of Central Sussex College. The college has a state-of-the-art theatre. A further multi-phased £30 million redevelopment scheme has reached completion.

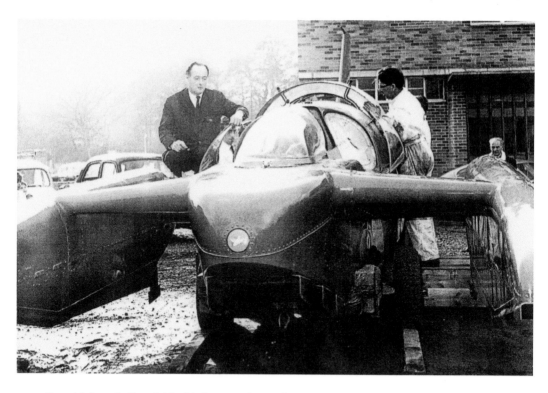

Donald Campbell and *Bluebird* at Norris Brothers' Premises, Burrell Road, *c.* 1966
On 4 January 1967, a split second away from breaking his previous water speed record of
276.33 mph, Donald Campbell's jet-powered boat, *Bluebird K7*, flipped over and he was
tragically killed. The design and development work had been carried out at Haywards
Heath by the Norris brothers, Lew and Ken, mainly at their premises in Burrell Road, Norris
House. Bluebird was ground tested in a shed adjacent to the offices – letters warning local
residents of the jet noise were circulated in October 1966! *Top: Donald Stevens.*

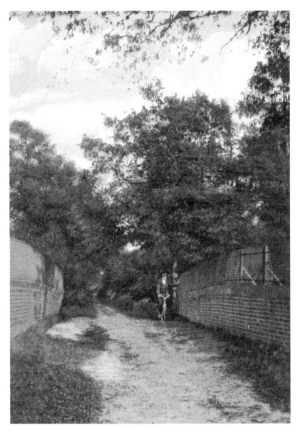

Ashenground Bridge, c. 1908
Despite the pace and volume of
modern development – especially
the big housing estates built from
about the 1960s onwards, the huge
phased development of Bolnore
Village to the west of Haywards
Heath and the forthcoming
completion of the new bypass to the
south – the town remains a 'green
and pleasant land'. Ashenground
Bridge spans the great Victorian
railway cutting driven through in
1841. Nicholas Hardham and other
'bound treaders' named on the 1638
map would have walked this way as
they surveyed the 'King's Highway'.

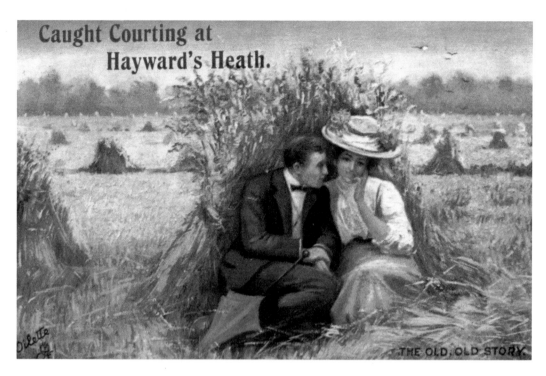

Caught Courting at Haywards Heath, Early Twentieth Century
It is difficult to place this scene; Haywards Heath was such a 'rural idyll' that it could have been almost anywhere. Modern Bolnore Village covers a greater area than the early settlement. New generations of families will grow up here looking to the future but hopefully conscious of the district's past, including the Roman road that runs through and the late Iron Age enclosure, discovered by archaeologists in the Bolnore Village Phase 3 housing area in 2004. *Top: Rogers Collection, West Sussex Record Office.*

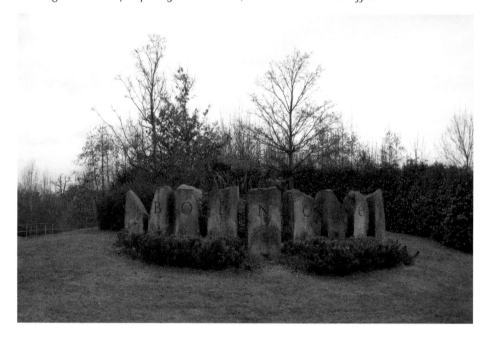